HOW TO

BUY AND SELL

USED

CAMERAS

DISCARD

DAVID NEIL ARNDT

AMHERST MEDIA, INC. ■ BUFFALO, NY

DEDICATION

For Suzanne, my bride. I forgive you for packing the cola next to the Canon F1 back in 1979. Love, David

Photos by: David Neil Arndt; Canon; Christie's; The International Photography Hall of Fame and Museum; Leica; National Air and Space Administration (NASA); Olympus, and Ken and Janice Wheatley. Photographs provided by Christie's, South Kensington Ltd. are copyrighted by the company and may not be used without permission.

Published by:
Amherst Media, Inc.
P.O. Box 586
Buffalo, N.Y. 14226
Fax: 716-874-4508
www.AmherstMedia.com

Publisher: Craig Alesse
Senior Editor/Production Manager: Michelle Perkins
Assistant Editor/Copy Editor: Matthew Kreib
Assistant Editor: Barbara Lynch-Johnt
Scanning Technician: John Gryta

ISBN: 1-58428-035-2
Library of Congress Card Catalog Number: 00-132630

Printed in the United States of America.
10 9 8 7 6 5 4 3 2 1

TABLE OF CONTENTS

INTRODUCTION

This book will provide you with all you need to know to buy and sell used cameras. It will help anyone interested in buying the best photographic equipment for the least amount of cash and earning as much money as possible from the sale of your cameras, lenses and accessories. From this book, readers will learn how to:

■ INSPECT AND TEST CAMERAS LIKE A PROFESSIONAL

This book details how to inspect and test cameras and lenses to discover hidden problems that affect function and price.

■ BUY PHOTOGRAPHIC EQUIPMENT FOR THE LOWEST PRICE

Your negotiating skill will grow as you learn the secrets of buying and selling used cameras and accessories. This book examines all of your negotiating options and discusses the pros and cons of various approaches.

■ DETERMINE APPROXIMATE RETAIL AND WHOLESALE PRICES

You'll learn how to use several publications to estimate an item's retail and wholesale value before you buy or sell any photographic equipment.

■ FIND THE ITEMS YOU NEED

Everything that a photographer might want is available—if you know how and where to look. Finding both the common and rare items you need will be easier with the tips contained in this book.

■ SELL CAMERA EQUIPMENT

This book will make finding buyers for your camera equipment a pleasurable, manageable and profitable experience.

■ DETERMINE WHERE TO GET AND MAKE THE BEST DEALS

This book will teach you how to find the best parts of the world to buy or sell used camera equipment as well as how to get the most (or the most for your) money.

This book will provide you with all you need to know to buy and sell used cameras.

1

WHY BUY OR SELL USED CAMERAS?

Buying used cameras, lenses and accessories can be an inexpensive way to acquire working equipment. Buying used equipment from retailers allows photographers to save between 10% and 40% of the retail price of new equipment. There are notable exceptions, however. Leica cameras tend to hold their value better than other equipment. Used Argus cameras are very difficult to sell, as are off-brand items and bottom of the line point and shoot cameras.

For some people, buying and selling cameras and accessories is a way to support their camera collecting hobby. Hobbyists sometimes buy equipment in an attempt to make a profit on its resale. The profit is then invested in buying more expensive or more interesting items for their personal collections. It is possible to earn a living from buying and selling used cameras and accessories, and many people make a living at this trade without ever opening a retail store.

Hunting for exactly the right camera or accessory is a pleasurable activity for many people. The search is often interesting,

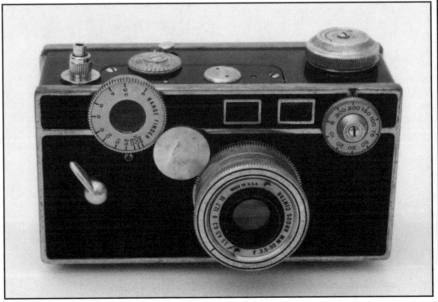

Argus cameras, like this 35mm C2, are not in demand and are therefore difficult to sell. Photo by David Arndt.

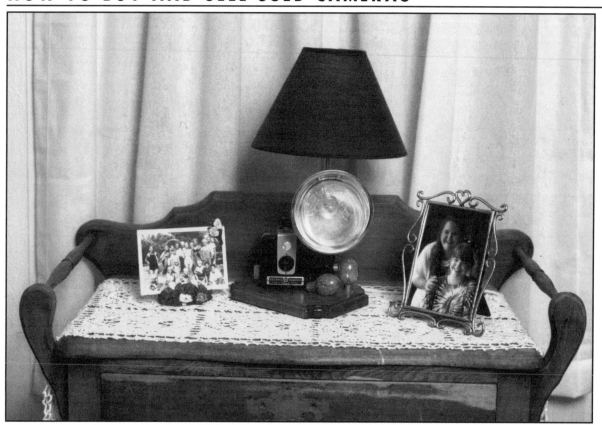

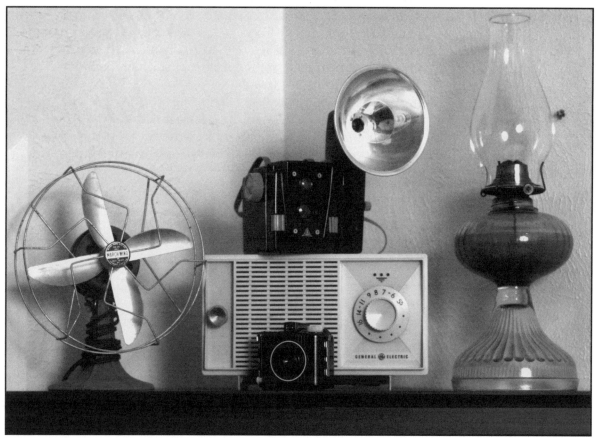

(Top) Some cameras are used as decorative objects. They can be displayed on bookcases or under glass. This Kodak camera, for example, was converted to a tabletop lamp. (Bottom) Old cameras can be displayed by themselves or as part of a group. Photos by Ken Wheatley.

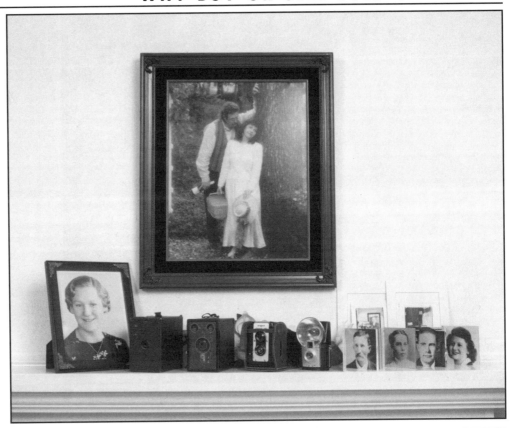

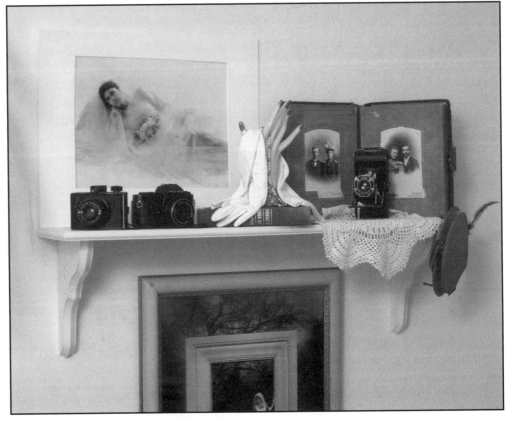

(Top) A camera collection makes a nice accent to a display of family photos. This is especially nice if the family owned the cameras. (Bottom) Janice Wheatley decorates her photography studio's sales space with old and new cameras, old and new pictures and a wedding dress. This sets a positive mood for the customers. Photos by Ken Wheatley.

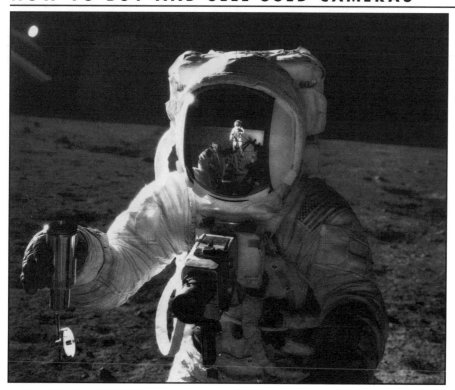

Astronaut Alan L. Bean holds a soil sample container while Astronaut Charles Conrad Jr. takes a photo with one of the highly modified Hasselblad cameras astronauts wore strapped to their chests. Conrad is reflected in Bean's helmet. The picture was taken during the Apollo 12 Lunar mission, and shows an example of a camera with high historical value. Photo courtesy of NASA.

because examining the item can be intellectually challenging, and negotiating the price is an exciting adventure. Finding a bargain is a thrill, especially if the seller does not know the value of the object he is selling.

■ STATUS OF OWNERSHIP

Certainly, camera ownership confers a certain prestige and status upon the owner. Rare or expensive pieces of equipment afford their owners a greater amount of respect from other camera collectors and photographers.

■ HISTORIC PRESERVATION

The preservation of family, local or national history can be an important motivation for camera enthusiasts. My great-grandfather Josiah Slater was an amateur photographer in the Upper Peninsula of Michigan early in the 20th century. He used a 4"x5" glass plate camera. Only eight of the original negatives that he made still exist. No information on the brand or model of camera he used is available. If the camera had survived, it would be a family treasure equal in historic value to any other heirloom, including our family Bibles.

Some museums seek out, own and display cameras that were used to take famous photographs, or were used by famous photographers.

From time to time, NASA sells cameras that were used on the Moon or in space. Christie's South Kensington once sold two highly modified Leicas that were made for NASA. Such cameras

Some museums own cameras that were used to take famous photographs.

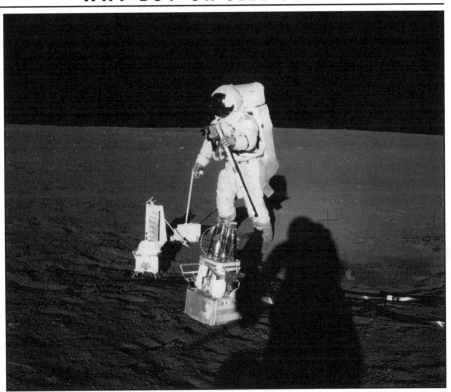

Astronaut Charles Conrad Jr. snapped this image of Astronaut Alan L. Bean working on the moon during the Apollo 12 mission. Again, notice the Hasselblad camera. Photo courtesy of NASA.

are highly sought after by well-financed collectors and museums.

■ USED CAMERAS CAN BE MORE PROFITABLE THAN NEW CAMERAS

Industry insiders report that used cameras and accessories support profit margins between 40% and 75%, whereas sales of new cameras often earn a 5% or lower margin for retailers. Popular cameras or accessories are often even sold at a loss to attract customers into stores where more profitable items such as camera bags, electronic-flash units, filters and extra lenses can be sold.

2 WHAT TO BUY

Whether you are buying as an investment or for personal interest, there are a multitude of camera choices on the market today. Are you buying for active use? Is collecting a hobby? Are used and antique cameras a business or an investment? Your reason for buying used cameras strongly influences which cameras and accessories you purchase and the prices you pay.

■ A HYPOTHETICAL BUYING SITUATION

To illustrate the best way to approach a typical purchasing scenario, let's assume that I am a hypothetical camera enthusiast who is looking into buying a used camera for personal use. Some of these steps may vary, depending on your preferences, budget, and level of camera knowledge. However, this series of steps will show you one way to tackle this process in an informed and logical manner.

I would begin by sitting down and making a list of what I wanted and to what uses I would put that equipment. Since I want to actually use the camera (as opposed to merely owning it for its value alone), film must be easily available. I'd call someone who works at my neighborhood camera shop and ask which film sizes they carry. They would most likely answer Polaroid, 110, 135, APS, 120, 220, and 4x5, adding that odd sizes such as Minox are available but that they must be ordered from specialty suppliers.

I would probably go on to inform the camera shop employee that I am looking to buy a used camera. The clerk has recently learned of environmental regulations that have forced two Mercury batteries, the PX13 and the 625, to be discontinued. These batteries powered hundreds of camera models from the 1960's through the 1990's. The clerk says that a substitute battery is available but that it sometimes causes erroneous light meter readings and poor exposures because the voltage output and the shape of the battery are different. I would thank the attendant for the advice, making a note to myself to check battery availability for any camera I am considering.

Next, I would consider the kinds of pictures I'd like to capture

There are a multitude of camera choices on the market today.

The condition and operation standards set by some camera collectors virtually require that the camera be stored in a plastic case and never used. Fortunately, most people buy used cameras for personal use and are willing to accept some minor signs of use. Photo by David Arndt.

with my used camera. I decide that I'd like to photograph the sights I encounter in my free time. While I admire the cameras and lenses carried by the professional photographers I meet, I recall that they complain about carrying a heavy load. They sometimes tote three cameras with motor drives and six different lenses. I don't want to carry that much stuff around with me, nor do I want to spend $40,000 for a complete photojournalist's outfit. I ponder

I don't want to carry that much stuff around with me, nor do I want to spend $40,000.

this problem and talk to the camera store employee again, who suggests that I consider an auto-focus, autoexposure camera with a built-in flash, motor drive and an optional zoom lens. At the camera store, I look at several different models and am impressed with the do-everything Nikon camera.

Now I have to decide between 35mm film and the new APS format. I notice that APS cameras tend to be smaller and lighter than similar 35mm cameras. Size and weight are important qualities to me, as I like to travel light. Next, I compare the technologi-

cal features of the two film formats. I learn that APS cameras are easier to load and that the developed film is returned in the original cassette for neater storage and retrieval than is possible with 35mm. I am somewhat disappointed to learn that the universally available 35mm film creates images in just one format, compared to the three different formats that can be generated using APS film. The camera store attendant has a used Nikon APS camera with all the features I am looking for (and luckily he is interested in selling his own used camera!), and he lets me shoot a test roll of film. This is probably the single most important step, as it gives me the chance to take some pictures with the camera and see how it feels when I use it.

After weighing the variables with the information I have gathered, I decide to buy the camera store employee's used Nikon APS camera with a built-in wide angle to telephoto zoom lens, motorized film advance and rewind, and a built in flash. The model I buy is still available new, but the used Nikon I purchase saves me about $80—and the camera is in perfect condition! This is definitely a success story, since I've purchased a camera that I know from research suits my needs, and also saved a few dollars. This is only the beginning of the possibilities of buying and selling used cameras.

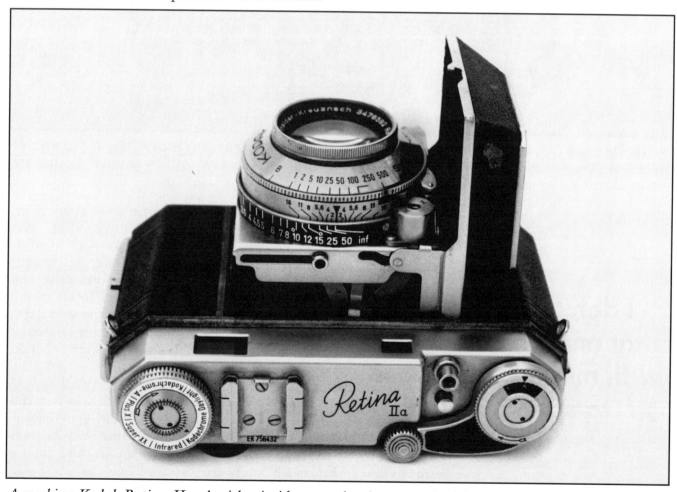

A working Kodak Retina IIa. A sticker inside states that is was serviced by a Kodak technician in Dallas, Texas, in 1963. Photo by David Arndt.

Old Leica rangefinder cameras that are clean and functioning (like the two pictured above) are in high demand and therefore might sell for more than their original retail prices. Photos courtesy of Christie's South Kensington Ltd.

■ WHAT'S AVAILABLE

From Argus cameras to Zeiss lenses, everything photographic is for sale. Photographers have abundant choices in the used camera market, limited only by the size of their budget. However, too many choices can lead to confusion, indecision and frustration. Since its invention in 1839, tens of thousands of different models of cameras have been made by thousands of different companies. The good news is that, while dealers need to buy items from many different manufacturers to meet the needs of their different customers, individual buyers can generally narrow the field to products

If history interests you, then consider cameras from an interesting era such as WWII. This Combat Graphic dates from WWII. It uses 70mm film, which is still used by portrait and school photographers. Photo courtesy of Christie's, South Kensington Ltd.

The Olympus Pen-F was a popular camera that used half of a 35mm frame for every picture; hence, it could place 72 pictures on a 36 exposure roll of film. Photo courtesy of Christie's South Kensington Ltd.

designed to work with their camera model. Obviously, it is silly to buy a Pentax zoom lens that won't mount on your Viet Nam era Nikon F (unless, of course, this Pentax lens is purchased for re-sale to someone with a compatible Pentax camera).

■ SPECIALIZATION

Almost every camera and lens ever made in quantity is available for purchase somewhere. Civil War era cameras can be found, as can the newest mega-pixel digital cameras. Even cameras that have been to the moon have been sold to camera collectors. Knowing enough about all of these types to collect them wisely is almost impossible. That is why people who collect cameras as a hobby also tend to specialize (although there is no need to do so if the units are for display purposes only). Sometimes a collector will focus on a single brand of cameras, while others narrow their interest

From Argus cameras to Zeiss lenses, everything photographic is for sale.

even more. For example, one collector that I know of is trying to collect all 39 recognized variations of the Kodak Retina series of cameras. Others own cameras that are built by other companies but which accept the Leica screw mount lenses.

■ BRAND SPECIALIZATION

Many photographers choose to buy used Minolta, Yashica, Nikon, Canon, Pentax, Kodak, Olympic or other brand-name cameras because they learned how to take pictures with their parent's camera, which was made by the same company. This is enough to create brand loyalty.

A few photographers choose cameras by a maker whose products they could not afford in the past. Leica and Hasselblad cameras fit this category. These cameras are also the most sought after by the used camera buyers. Some used models sell for more than their new retail price. There are even Leica models made for commemorative purposes or just for the collector's market.

This Ticka brand camera conceals the lens in the winder mechanism. A lens cap is attached to the chain. The Ticka was so big it would fill the palm of most adult hands. Photo courtesy of Christie's South Kensington Ltd.

■ FILM FORMAT SPECIALIZATION

Specializing in a single film format can be an interesting hobby. Here is a list of some well-known film formats:

ROLL FILMS
16mm, 35mm (135), 70mm, 116, 117, 120, 127, 220, 620, 720, 828

CARTRIDGE FILMS
110, 126, APS, Disk, Minox

SHEET FILMS
4x5, 5x7, 8x10, glass plate, Polaroid, Kodak instant picture.

■ 'SPECIAL USE' SPECIALIZATION

Buying special purpose cameras is another option. Many collectors like to acquire: movie cameras; cameras grouped by the nation of the manufacturer; panoramic cameras; premium and promotional cameras; spy cameras; aeri-

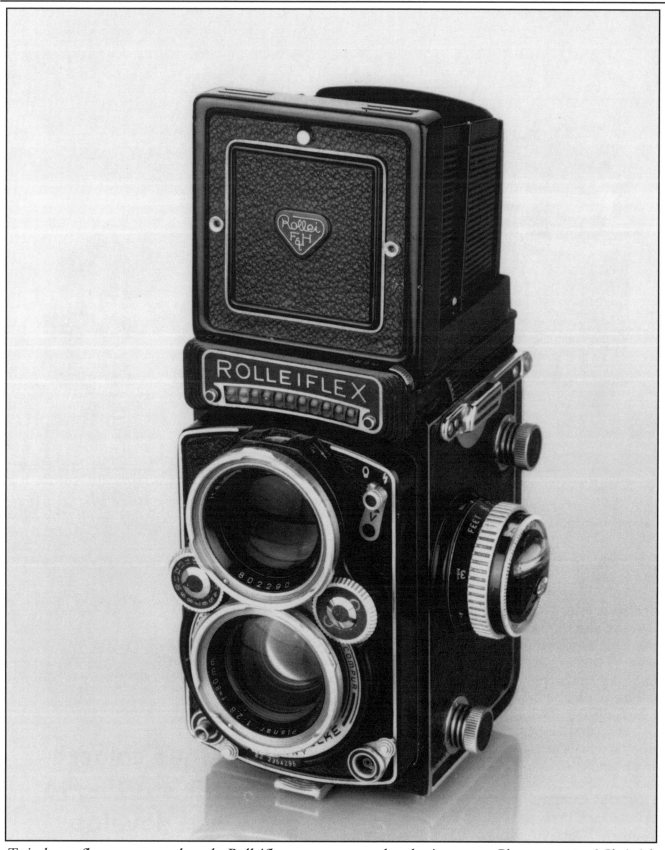

Twin lens reflex cameras such as the Rolleiflex are a very popular classic camera. Photo courtesy of Christie's South Kensington Ltd.

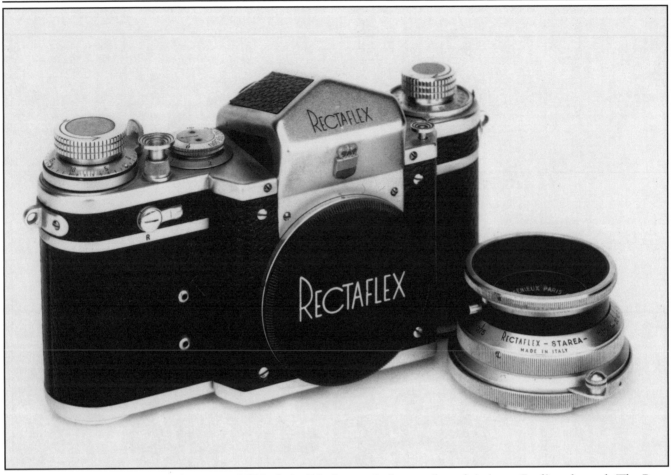

This Rectaflex SLR camera is stamped "Made in Liechtenstein" even though it is an Italian brand. The Lens is marked "Made in Italy." Cameras have been manufactured throughout the world, and location of manufacture is one type of specialization among camera collectors. Photo courtesy of Christie's, South Kensington Ltd.

al cameras; stereo cameras, and toy cameras.

■ FAMOUS PHOTOGRAPHERS' CAMERAS SPECIALIZATION

A few museums and collectors collect cameras used to take famous pictures or owned by famous photographers. In this market, documentation of previous ownership and use is more important than the condition of the camera.

■ ANTIQUE CAMERAS

Ed Sandbach is the Professional Products Manager for Warehouse Photographic and Lab in Carrollton, Texas. In his job, he buys and sells many used cameras every week. He has also been a collector of antique cameras. He is most personally interested in cameras with lens bellows.

"The antique camera market is starting to grow and develop into a worthwhile market. Fifteen years ago, it was very hard to sell antique cameras. I used to collect them at that point because they were so cheap to buy. I ended up with about a hundred antique cameras. I ended up selling most of my cameras... and at this point I have only about fifteen left. I ended up selling most of my collection and making a 200 or 300 percent

The antique camera market is starting to grow and develop.

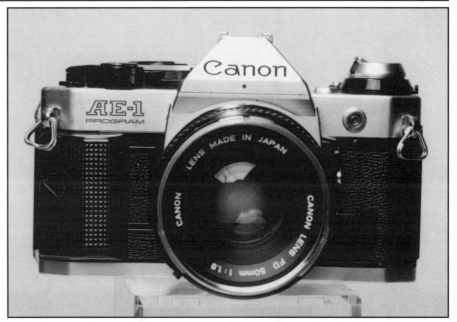

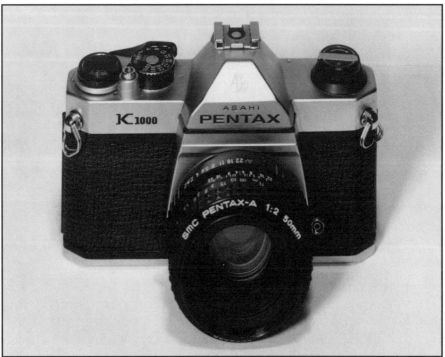

(Top) The Canon AE-1 and AE-1 Program are extremely common cameras, yet they have held their value well and are still in demand around the country. However, their prices change from state to state. (Bottom) The camera store that loaned me this Pentax K1000 priced it at $225 in the fall of 1999. That is $100 more than its new price one year before. Photos by David Arndt.

profit. I could have made about a 500 percent mark up if I had waited and sold to the right person. In the market now, the demand is there," Sandbach reports.

"In antique camera collecting, condition is the primary factor. If you have the box and the instruction book, and if the bellows are extremely clean, the better the price. The antique camera should

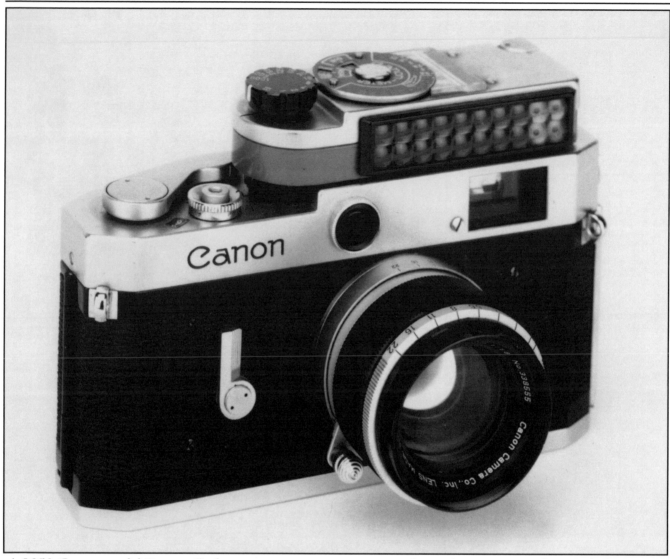

A 1959 Canon model P rangefinder camera accepts screw mount lenses from many makers including Leica and Nikon. Photo courtesy of Christie's South Kensington.

be in practically mint condition; a lot of them aren't, but the ones that are in mint condition are very easy to sell. You can get top dollar for them. A clean camera is definitely going to be an easier sell than a dirty camera. Wear and tear and dirt affect the price, and dirt is the easiest thing to fix," says Sandbach.

"I always wrapped and boxed my antique cameras individually and then put them away. I didn't like to display the cameras because there is so much dust in the air. The older cameras are fragile. The ones that I collected are bellows cameras, and bellows are vulnerable to dust. Some of the people that buy from me know this and care about how I take care of my equipment. They don't question me when I tell them how much I want for a camera, because the equipment looks good and has been well cared for. Some people leave them out on display all the time, and it looks bad if you have to wipe the dust off of them in front of the customer," Sandbach says.

Used photographic equipment prices vary from location to location.

■ REGIONAL VARIATION IN CAMERA PRICES

Used photographic equipment prices vary from location to location and nation to nation. London currently is the price leader in the world market.

"The reason why Christie's, on a worldwide basis, sells cameras and collectible photographic equipment purely in London is that the strongest part of the market is London. Prices tend to be higher here," said Michael Pritchard, who manages Christie's camera auctions in London. Christie's South Kensington is used by several notable US dealers and clients worldwide to sell cameras on the international market. Even the famous George Eastman House Museum in Rochester, New York, sells their excess inventory in London.

■ REGIONAL VARIATION IN DEMAND

In addition to camera prices varying from area to area, the products that are in demand also differ regionally.

"One thing I have really noticed is that Canon AE-1's are less expensive here [Dallas] than in New York or even Atlanta," Todd Puckett said. Puckett operates a used camera shop and hosts used camera shows.

He continued by using the Pentax K-1000 as an example. "When they were being sold new at the very end of their production, you could buy one new at a

Leica screw mount lenses like this one are easy to resell because they fit so many non-Leica cameras. Photo courtesy of Christie's South Kensington Ltd.

camera store for $125. But if you got it used at a camera show, it was $175. Dealers were buying them new at the store, taking them out of the boxes and selling them as used. This happened because teachers told students, 'Go buy K-1000s used; they are inexpensive and totally manual.' So the students went to the camera shows to buy K-1000s. People didn't realize they were still available new. Finally, Pentax dropped the line," Puckett said.

Sandbach reports that Warehouse Photo also gets a lot of business from Mexican photographers who travel to Carrollton, a Dallas suburb, to buy used professional level cameras and lighting equipment. "Many students

are buying their first camera for a class, a lot of professionals are looking for specific pieces and some amateurs are looking for exotic pieces such as super-wide and extreme telephoto lens." Sandbach said. "Beginning portrait photographers want professional cameras and professional lighting equipment," he said.

People didn't realize they were still available new.

"The lines that are in most demand are Nikon, Canon, Mamiya medium format, Leica, Sigma, Vivitar and Tokina lenses. Generic lenses are very hard to sell. Flashes are hard to sell, except for studio lighting sys-

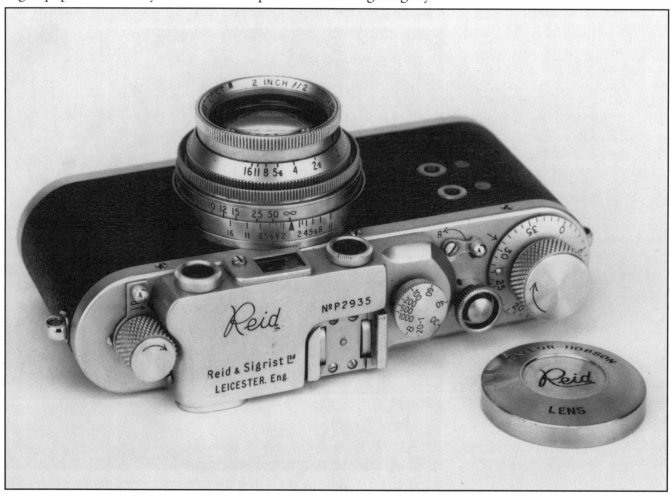

This Reid is one of a multitude of Leica clones that accept screw mount lenses. The Reid is said to be a well-made camera, unlike some other Leica clones. Photo Courtesy of Christie's South Kensington Ltd.

tems. We only get one or two lighting sets a year, and if they are priced right they generally sell within one or two weeks," Sandbach said.

"Leicas are a much higher priced market, and Leica customers are going to be a lot more finicky about condition than a Canon or Nikon customer. There are also Leicas made in Canada and Singapore that collectors will always try to get a good deal on because it was not made in Germany. Some of the Leicas, like the M6, sell for more used than they did new," Sandbach reports.

Flashes are hard to sell, except for studio lighting systems.

"There are a lot of people getting out of the darkroom now because of digital photography, so currently there is a flood of enlargers and developing equipment on the market," Sandbach said.

Sandbach's comments reinforce the fact that ample research is needed by buyers to determine the equipment they wish to purchase as well as the best place to purchase it. Starting with solid research is the key to making the right purchase at the right price. It's a little extra work, but the extra effort will almost always pay off.

3
SUCCESSES AND DISASTERS

The first set of vignettes in this chapter are meant to illustrate how photographers can save money by looking to the used camera market for the equipment they want. They should serve as examples of the potential savings that this market has to offer and will hopefully inspire you to go out and search for your own bargains.

The second set of stories offers some examples of what can happen to buyers who are don't take the time to fully inspect their purchases, or are lured in by a low price.

■ **SUCCESS STORIES**
Wedding photographers save big with used camera kit. Ken and Janice Wheatley operate a busy part-time wedding and portrait photography business in Plano, Texas. In 1998, they decided to invest in a medium format camera for their portraiture work. The Wheatleys borrowed a Mamiya 645 from a friend and successfully completed several projects. Convinced of the benefits of medium format cameras, and happy with the Mamiya, they started searching for a used camera system of their own.

A friend, Mary Grace Bartoo, was trying to sell her Mamiya RB67 camera at the same time. The RB67 series of cameras is very popular with photographers working in posed portraiture styles. One advantage of the RB67 is that its negative proportions exactly match that of 4"x5", 8"x10" and 16"x20" prints (this is called "ideal format"). The Wheatleys shot some test rolls with the Mamiya and negotiated with Ms. Bartoo. Ms. Bartoo paid $100 for the repair of a sticky cable that connects the lens to the camera body, and the Wheatleys paid $2,000 for the camera body, two 120 film backs, a 90mm f-3.5 normal lens, a 150mm f-4 soft focus portrait lens, a prism viewfinder, Polaroid back, camera grip and a camera case.

They saved $5,000 by purchasing the system used.

An examination of advertised prices for new versions of these same items reveals that the Wheatleys would have spent about $7,000 for these items. This means that the couple saved $5,000 by purchasing the system used.

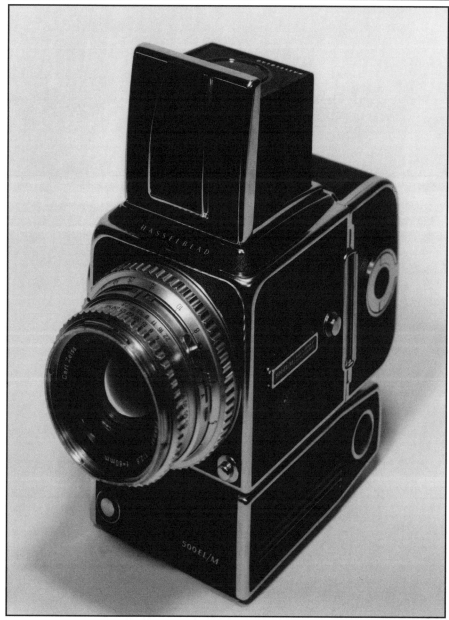

This Hasselblad 500/ELM is similar to the one purchased by Phil Morgan in 1998. Photo by David Arndt.

Photographer stays in budget with used lenses. Over the years, as special needs have occurred, buying used lenses has helped me keep spending under control.

In 1998, I needed a 300mm Canon FD mount lens to shoot some color sports action. The 300mm f-2.8 lens I wanted was available for between $2,000 and $5,000, depending on its age and condition. Since even the least expensive new copy of the desired lens was beyond my price range, I chose a Canon 85mm to 300mm zoom lens instead, paid $850, and saved between $1,200 and $4,500. This lens was, however, missing the front retaining ring, which is used to display the lens brand, focal length and serial number. Since the missing part does not actually hold the front lens element in place, it was merely a cosmetic problem and did not affect lens quality or operation.

In 1999, I purchased three lenses for my Toyo view camera. I bought a new Nikon 135mm f-5.6 lens for about $750. A week later, I bought a used 210mm f-5.6 lens and a used Fujinon 420mm f-8 from a neighborhood camera shop for a combined price of $750. This was half the asking price and several thousand dollars below the prices for the same optics if purchased new.

Patience saves Dallas photographer cash. Phil Morgan is a regular buyer of used cameras. He is a professional photographer in Dallas, Texas, who purchases cameras from friends and mail order companies, as well as retailers. In 1998, Morgan spotted an offer on a professional photo lab's bulletin board for a Hasselblad ELM body. This version has a built-in motor drive. A photographer he knew posted the notice and was asking $800 for the body. "I waited for the price to drop and got the body for $650," Morgan said.

Back in 1992, he purchased a used Nikon FM2 with a normal lens from a New York City mail order house for less than $500. "It was in perfect condition," Morgan said. Morgan has also

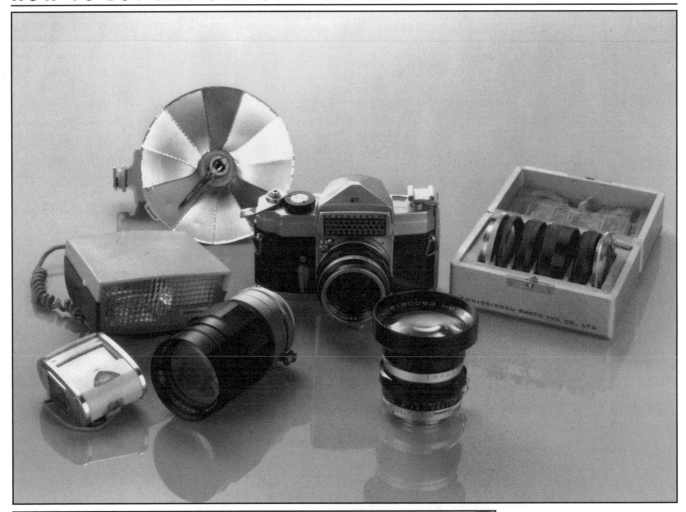

(Top) Except for the bulb-type flash gun, this Konica outfit is still fully functional, if not on the cutting edge of auto-everything electronics. Its mechanical simplicity is viewed as an asset by many experienced photographers who fear battery failure.

(Left) This Leica IIIf kit is fully mechanical, yet it is sought after by photographers looking for superb optics and quiet operation in a small and light unit. Photos courtesy of Christie's South Kensington Ltd.

purchased a Nikon 35-105 zoom lens with macro capabilities for $250 from a Dallas camera shop. "I never had any problem with any of the equipment I bought. But then again, I don't walk down the alley to see what is offered out of the back of a truck. You have to be careful who you buy from," Morgan said.

Pendelton pushes used camera purchases. Jackie Pendelton, the 1998 President of the Dallas Professional Photographers Association, wrote an editorial advocating buying used professional level cameras in *Exposed*, the Dallas Professional Photographers Association newsletter. "I've had good experiences buying used cameras. Used cameras are the only kind I ever buy. I never even look at the new equipment. Of course, I only buy top of the line name brand cameras," she said. "I've bought three Hasselblad systems, several lenses and backs without any problem," she said. "Good cameras hold their value. I paid about half of the new retail price." Pendelton also had positive experiences selling her used large format camera and accessories, which sold rapidly and at a reasonable price.

Criminals, and con-artists occasionally try to defraud used camera buyers.

■ DISASTERS

Dealer caught switching lenses. Sharp operators, cheaters, criminals, and con-artists occasionally try to defraud used camera buyers. A Midwest camera show organizer, who asked to remain anonymous, once received a complaint about an independent vendor that rented a table at a small show. A customer complained that when the dealer bent down under the table to place the chosen lens in a bag he switched the lens with a poorer quality example of the same make and model. The show promoter confronted the dealer on behalf of the customer, obtained the correct lens and expelled the dealer from that show.

Another similar trick used by shady camera dealers is to mount an old lens on a newer camera body.

Damaged camera resold many times in neighborhood. Suzanne Arndt is a professional photographer and manages a photo processing lab. She tells of a fellow that bought a red Canon Snappy point and shoot camera at a garage sale. The owner brought the camera in to Suzanne and asked for help. He could not get the camera's shutter to work. Suzanne took a quick look at the camera and remembered it. It would be sold at a local garage sale every three or four months to an unsuspecting buyer and the new owner would bring it to Suzanne to be checked out. "That camera has been circulating from garage sale to garage sale and new owner to new owner for over two years. Next time it comes in I might use a black marker and write 'broken' on it so no one else gets taken," Suzanne said.

Whenever you purchase used equipment, know what you are buying and double-check your purchase before leaving the counter. Used photographic equipment can be an excellent bargain, but it pays to exercise caution and keep your eyes open.

4
CAMERA ABUSE

When shopping for a used camera, it pays to keep in mind that cameras are often used (and abused) in ways that one wouldn't normally imagine. The following stories illustrate some of the general types of camera problems to look out for. In the next chapter, we will examine a case study dealing with a single camera and the flaws that a careful buyer will be able to spot immediately.

■ MISALIGNED LENS ELEMENTS

In 1971, I purchased a 50mm macro lens and took my Canon Ftb camera and a case full of lenses to the University of Michigan's Matthei Botanical Garden, just northeast of Ann Arbor. I spotted a flower to photograph near the driveway. I placed the camera case on the pavement next to the curb and turned around to shoot the flower. A moment later, a car backed into the empty parking space and caught the case under its right rear tire. The driver never saw the black case. Foam padding in the case kept the lenses from being crushed, but they were knocked out of alignment. A 20mm, a 28mm, and a 135mm lens all needed repair. Luckily, my insurance paid for the realignment necessary to get the optics in focus.

Camera stores often test the mechanical functions of the used lenses they sell, but they generally cannot test the optical quality because the test equipment is very expensive and difficult to use and interpret. Because there was no visible damage to the aforementioned lenses, a used lens buyer would not detected the damage until the first pictures came back from processing. Lesson: a cautious buyer will always test equipment before purchasing it to avoid getting stung.

A buyer would not have detected the damage until the first pictures came back.

■ MECHANICAL DAMAGE

The first year I started photographing for money was 1972, and I paid a friend $25 for a Mamiya C22. The friend, a photographer for Eastern Michigan University, had become angry at the camera's tendency to jam. He and a photographer from the Ypsilanti Press played a short game of soccer with the body. They kicked the C22 across a basement floor for a few min-

utes. Afterwards, they placed it on top of the furnace and left it there to collect dust for a year.

After a good internal and external cleaning, I purchased a used 80mm $f2.8$ lens and shot portraits and basketball action with the C22 for two years. However, the gears that advanced the film would slip from time to time and produce an unplanned double exposure. Other times, the shutter button linkage would fail to trip the shutter. Since I knew the camera's history, these failures did not faze me. I expected the problem and was always prepared to compensate by shooting more film than I needed.

In 1983, the C22 body was tossed into the trash and the lens was sold. Lesson: well-used and sometimes even abused equipment can sometimes perform adequately. Knowing the history of the camera, I was prepared for this and could compensate. However, this damage might have been far less acceptable to an unsuspecting buyer looking for a properly-functioning camera.

They kicked the C22 across the floor for a few minutes.

■ **HEAT DAMAGE**

Heat is the invisible enemy of cameras and lenses. I once kept a Mamiya C33 twin lens camera system in the trunk of my Volkswagen Rabbit. In August 1982, I was shooting for The *El Dorado News Times* in hot and sunny southern Arkansas. One afternoon, the car was parked in the sun for a few hours. When I used the camera with a 180mm lens, I could not focus a sharp image in the viewfinder. An investigation by a local camera technician discovered that the glue that held two pieces of glass together in the viewing lens had melted from the heat. The lenses separated, and a fuzzy layer of glue was left between the elements. The cost of repair was more than the value of the lens, so I eventually gave the lens to the technician for his collection of damaged equipment.

That same summer, Suzanne Arndt had a bad experience with her flash. While she was a photographer for *The Camden News* in Arkansas, she left the flash in the trunk of her Toyota for ten minutes while she photographed a check presentation. Upon her return, she noticed the plastic body of her flash had warped from the heat. Later that day, a darkroom thermometer placed on the dashboard of her closed car reached 145° Fahrenheit in just eight minutes. The outside temperature was only 90° Fahrenheit at the same time.

The lesson? Some heat damage (such as the warped casing on the flash unit) may be easy to spot with a close physical evaluation of the equipment. Other types of heat damage (such as that to the lens) may only be detected by actually putting the equipment to use.

■ **WATER DAMAGE**

Some damage is not repairable. Outside of dropping a camera off a cliff or throwing it into an inferno, water is possibly the quickest way of causing permanent damage to a camera. Water washes away delicate lubricants, short circuits electronics and quickly rusts tiny steel parts.

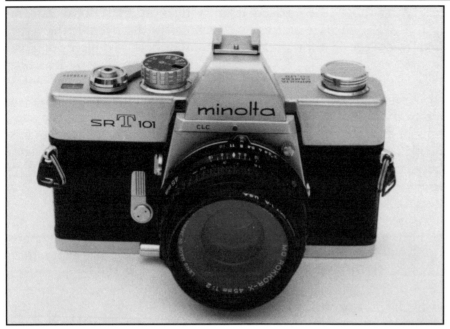

This Minolta SRT 101 is similar to the one I used as a "rain camera" in Arkansas. Photo by David Arndt.

Newspaper photographer Jim Zerschling tells the story of a house fire he photographed in a rural Midwestern community. Zerschling went about his business of photographing the flames, building and fire fighters. After the blaze was under control, a volunteer fireman decided to turn the water hose on Zerschling. He drenched Zerschling, three Nikons, his lenses and a camera case. The fire department and the city refused to replace Zerschling's ruined equipment, so he filed a complaint against the city with the National Press Photographers Association. The association threatened a lawsuit, and the city finally replaced Zerschling's ruined cameras and gear.

Water damage is such a common problem that some photographer's assign a second string camera for use in the rain and other potentially wet situations. When I worked for the *El Dorado News Times* in Arkansas, the newspaper supplied me with a Minolta SRT101 SLR camera. Since I preferred to use my Canon cameras on most assignments, the Minolta was used exclusively when there was a possibility that the camera would be damaged. It became known as the "Rain Camera." I frequently photographed traffic accidents and football games in the rain. The rain would soak the Minolta by the time the assignment was over. To dry the camera, I would remove the lens, open the back and then hang the body up to dry in the darkroom. It is a testimony to the quality of Minolta cameras that the camera kept working despite this recurrent abuse.

Water damage, as noted, can cause rust which should be looked for before purchasing any camera equipment. Short circuited electronics and poor lubrication are trickier to detect and

The rain would soak the Minolta by the time the assignment was over.

usually identified only by using the equipment and testing electronic functions.

■ OTHER FLUID DAMAGE

Carbonated cola drinks can be insidious, with the capability to ruin cameras. In 1979, I took a road trip across Michigan. My wife and I packed a lunch and the camera into the back seat and headed for the Sleeping Bear Dunes State Park on Lake Michigan. Somewhere along the way, cola bubbled out from under the poorly sealed cap of a previously opened bottle and spilled onto a new Canon F1 camera body. The sticky fluid penetrated into the gears and the shutter. Consequently, everything froze.

The sticky fluid penetrated into the gears and the shutter.

The first technician I took it to agreed to try to clean the sticky stuff out of the camera. He thought he succeeded. The F1 worked for a few months, but shortly thereafter the unit lost its flash synchronization. "Worst mechanism I ever saw," said the second camera repairman to fix the camera. "Its working now, but I don't guarantee it will work tomorrow," he said. The fifth time the flash synchronization failed, that technician refused to even look at the camera.

The original price of the F1 body was $310. I invested a total of $450 in repairs. Each repair was less expensive than purchasing a new F1 body, so it seemed economically wise to attempt repair after repair. After spending $760, I was left with a camera body that is only good for a boat anchor or paperweight. A better investment would have been to purchase a used F1 body. In 1999, the cola camera was sold to a camera technician for $75. He uses it as a source of parts. This camera is used in the next chapter as a means to illustrate the many flaws that any camera shopper, armed with the right information, can easily spot.

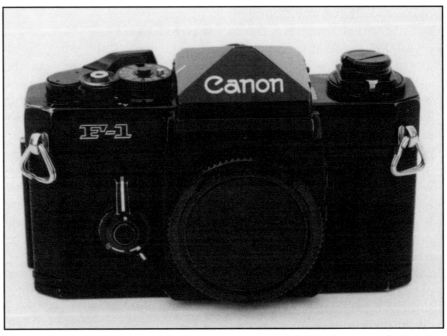

This is my cola camera, which cost me a great deal of money ($760) for several fruitless repairs. Photo by David Arndt.

5 DAMAGED CAMERA CASE STUDY

My 1979 Cannon F1, the "cola camera" (described in the previous chapter), is a wonderful case study. It illustrates a wide variety of problems that can be discovered by an observant buyer. No testing equipment is needed to spot these problems. The following describes and illustrates the visible problems with this particular camera.

■ DENTS

The body has many dents (see photo on opposite page). This shows that the camera has had heavy use. It has been bumped against other objects. Dents reveal the possibility of hidden internal damage.

■ MISSING PAINT

The ring that holds the neck strap to the camera has worn the paint off the body (see photo on opposite page). This is normal wear and tear and does not indicate any problem; it is merely unsightly. Missing paint at other places is an indicator of frequent use. Professional photographers almost never use the camera cases that come with some models. These cases slow down the film changing process because they have to be removed before the camera back can be opened. They are heavy, awkward and get in the way of active photographers. This generally means that professional level cameras get little or no protection from scratches and dents when in use. Again, signs of heavy use may be only cosmetic, but should also provoke the cautious buyer to even closer inspection and testing of the camera's proper functioning.

Dents reveal the possibility of hidden internal damage.

■ LOOSE PARTS

One of the bolts that hold the neck strap to the camera body is loose. Repair requires disassembly of the camera. The film advance lever is also loose. Tightening the lever requires a special pin wrench, but no disassembly is needed. These problems are symptoms of heavy use. Thousands of rolls of film have passed through this camera, but making these minor adjustments means that such equipment can continue to produce quality photographs for months and perhaps even years to come. Ask a trained technician to make these technical adjustments.

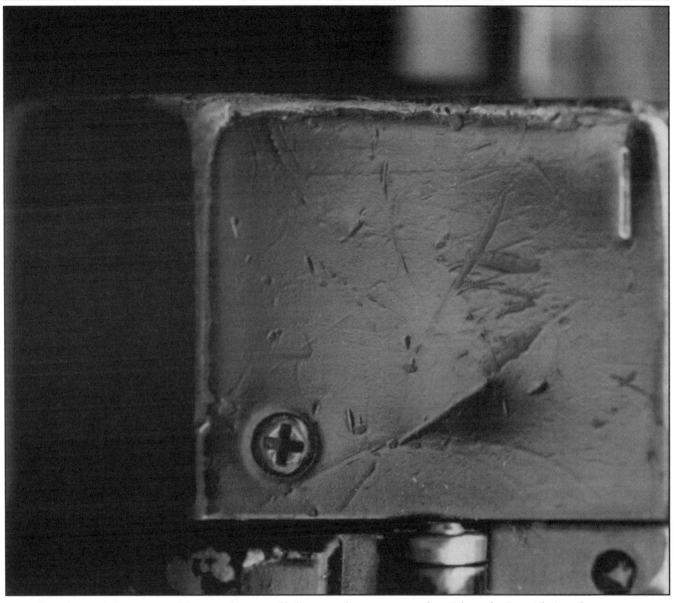

Side lighting of the Canon F1 reveals a small dent and many scratches. Photo by David Arndt.

■ MISSING EYECUP

The rubber eyecup on the viewfinder is missing. This, however, is an inexpensive part which can be replaced quite easily by a technician at your local camera repair shop.

■ BROKEN EXPOSURE COUNTER GLASS

The glass that covers the exposure counter is missing (pg. 37). Considering that it takes a pretty strong blow to break this item, the broken glass is a real red flag item. Beware of cameras with this level of damage.

■ JAMMED MIRROR

When you depress the shutter release button, this camera will not fire. A look inside of the mirror box shows the mirror is jammed halfway up (pg. 38). The broken exposure counter glass is probably stuck in the shutter gears. This is an expensive repair. Unless you are skilled at camera repair, put this camera down and buy a different Canon F1.

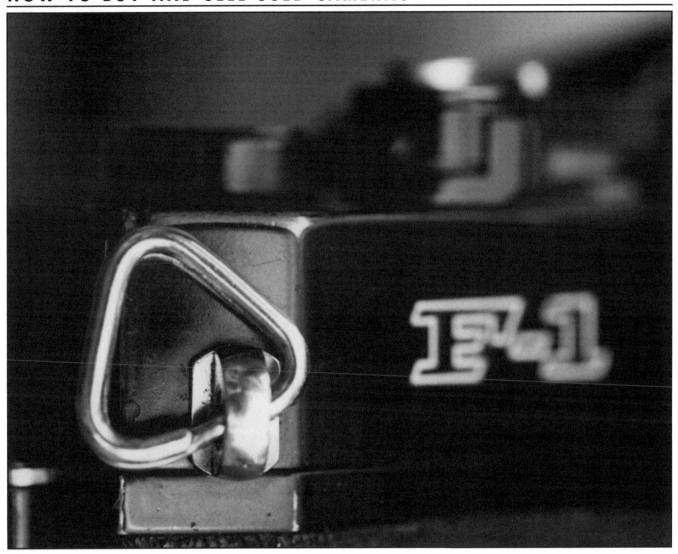

Metal neck strap rings will wear the paint off a camera in just a few hours of use. However, a buyer must ask whether it is more important to have a perfect looking camera or a slightly marked up bargain that works fine. Photo by David Arndt.

The glass over the exposure counter is broken and missing. This is a real red flag item. Photo by David Arndt.

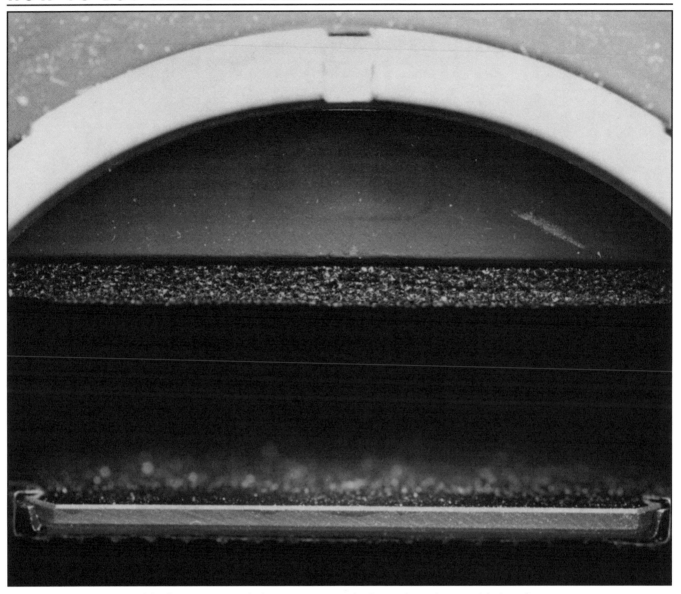

The mirror is jammed halfway up, and the camera won't fire. Photo by David Arndt.

■ FLASH SYNCHRONIZATION FAILURE

If the mirror had worked, shooting a test roll of film would reveal that the cola residue prevents the shutter from synchronizing with the flash.

■ STICKY LOW SPEED SHUTTER

Once again, if the mirror worked, a test would show that shooting at the lower shutter speed settings results in the shutter sticking open. This is another sign that it's time to move on to another Canon F1.

■ THE LESSONS

Two lessons can be learned from the cola camera.

First, you'll probably do well to avoid cameras that seem to have been heavily used. The way cameras are used by photojournalists, for example, can lead to significant abuse. These professionals carry their cameras in all types of weather. They get wet, frozen, filled with sand or covered with mud. Some photojournalist's cameras even get hit by bullets. Photojournalists often even brag

about how much they abuse their cameras.

Sometimes a store clerk will brag about a used camera that was used by a local photojournalist and claim it has been lovingly cared for because the photographer depended on it for her living. The story might be true. For most photojournalists, however, camera maintenance is an expensive luxury. Repairs are often unreliable and take too long. It is cost-effective for photojournalists to trade in an old camera for a new one every two or three years.

Other professional photography specialties are much easier on the cameras. Portrait photographers work in a less hazardous environment and therefore place less stress on the equipment. The best type of previous camera owners are the ones that shoot Christmas, vacation and birthday images and process their one roll of film every fall.

Second, if you already own a damaged camera, don't repair it multiple times. Camera repair people tend to have a minimum charge for most repairs. This is to cover their time. Many jammed cameras are easily unjammed by removing torn film fragments and any other foreign matter from the camera. The most basic repair is changing a dead battery. But when a light meter stops working or when the shutter fails to open, the cost of "out of warranty" repairs for many cameras might be too high to justify the repair. My personal standard is not to repair a camera when the projected expense is half the cost of a new or used replacement camera.

> ## For most photo-journalists, camera maintenance is an expensive luxury.

6
CONDITION RATING SCALES

Condition is the single most important factor in determining the price of most used cameras, and is also a useful indicator of the camera's potential useful lifespan. Since used camera sales experts report most used cameras are purchased for use rather than for decoration or for a collection, it makes sense to buy the most functional and reliable camera available in your price range.

■ CAMERA CONDITION RATING SCALES

Most mail order dealers and auction houses publish condition ratings for many of the items they sell. Condition ratings indicate usability of an item and (indirectly) the probable usable life expectancy. The condition ratings may also be considered moderately accurate as an indicator of function and appearance. Condition ratings are not commonly displayed for customers shopping in retail stores because there are abundant opportunities for buyers to examine and test the merchandise in those settings.

The catch in interpreting a mail order or auction rating is that the ratings suffer from word inflation. Word inflation is similar to job title inflation. A garbage collector becomes a sanitation engineer, a secretary becomes an executive assistant and a school librarian is now called a learning resource manager. *Shutterbug* magazine is a very popular source of used camera equipment, generally purchased by mail order. In the *Shutterbug* ratings (described below), the word "excellent," for example, is used in three of the eight ratings. What "excellent" means, therefore, varies dramatically within each of those categories.

■ SHUTTERBUG RATING SCALE

Shutterbug magazine advocates the following scale for use in their classified advertisements. Many of their retail advertisers also use the scale.

New: Never sold to a customer and never used; new as shipped by the manufacturer or distributor, with all the original packing and instruction materials. Merchandise sold as "New" must be eligible for full warranty services from the officially

Condition rating indicates the usability of an item.

authorized importer/distributor in the U.S.A. New items cannot be advertised in the *Shutterbug* classified ads.

Mint: 100% original finish. Just like factory new, but may not include original package material or instruction books. Must be pre-owned to qualify as Mint.

EX+ (Excellent Plus): 90 to 99% original finish. Used very little, but obviously used. No major marring of finish or brassing. Optics perfect. Mechanically perfect.

EX (Excellent): 80 to 89% of original finish. May have a finish flaw or two which detract from appearance, but must be mechanically perfect.

EX- (Excellent Minus): 70 to 79% of original finish. May have relatively large flaws in finish, which do not affect function. Must be optically and mechanically perfect.

The finish remaining on a camera is not a reliable diagnostic tool.

G (Good): 60 to 69% of original finish. Must be complete but may be scratched or scuffed. Metal may show wear but should have no corrosion, rust or pits. Must be optically and mechanically perfect.

F (Fair): 50 to 59% of finish. May or may not be perfectly functional, but all functional defects must be clearly stated in the ad. Would not be attractive to the eye.

UG (UGLY): 50% or less of original finish. Well used and worn. May have missing parts or may not be fully functional. All defects must be clearly stated in the ad.

One used camera retailer states that any camera given a *Shutterbug* "Fair" rating should be trashed. The author advocates caution when buying equipment with a rating below "Excellent Minus."

A major problem with the *Shutterbug* scale is its emphasis on estimating the percentage of original finish that remains on the unit. While there are certainly ways to scientifically measure paint wear it is probably impossible to visually differentiate between 75% and 80% paint remaining without years of experience. Furthermore, the amount of finish remaining on a camera is not a reliable diagnostic tool for evaluating a camera's functionality. My cola-damaged Canon F1(described in the previous chapter) still has more than 90% of the original finish, which would result in a EX+ (Excellent Plus) rating but mechanically it gets an UG (Ugly) rating because the shutter is jammed. Still, an appearance scale has some validity since most camera buyers never test a camera before purchase. The only way these buyers can judge is by appearance. Even with serious flaws, reporting a used camera's rating on a widely accepted scale is an important service that boosts the ethical and behavioral standards of the used camera industry.

■ MAIL ORDER RATING SCALE
A popular scale ranges from the worst at 0 to 10+ at the top. Each number except 0 can have a + (plus) or - (minus) sign after it.

This provides 31 fine gradations between condition levels. Mail order businesses do not waste their expensive advertising space on items with a rating below seven on this scale, so the usefulness of such a long condition scale is debatable.

Some mail order advertisers also use the following scale:

Mint: As new, but without packaging.

Mint–: Very fine condition and showing only the very slightest, insignificant signs of use.

E++: Better than average; signs of use, but nice and clean.

E+: Average condition; shows normal wear but looks okay.

E: Well used but not horrible looking.

E–: Very well used, unattractive.

VG: A bargain; ugly but well worth the price.

■ CHRISTIE'S RATING SCALE

Christie's South Kensington, the world famous camera auction house in the United Kingdom, uses a three-scale system. Numbers (1 through 7) indicate the cosmetic condition, and letters (A through D) report the mechanical condition; both of these scales refer to cameras as a general group. They relate primarily to the camera body, and specific defects may not be noted —especially to parts such as light meters and rangefinders. The third scale, represented by lower case Roman numerals (i-vi), refers to the condition of lenses in particular. They make it clear that "prospective buyers should always satisfy themselves as to the detailed condition of a lot [equipment sold as a group] and are referred to Christie's Conditions of Business" for further elaboration on their policies.

Christie's literature states that a good average camera will score 4B. Their condition scales are as follows:

Cosmetic Condition Scale
1—New. Factory condition, apparently unused.
2—Good condition. Minimal marks to camera body.
3—Light signs of wear.
4—Normal use and wear.
5—Heavy use and wear.
6—Restoration required, parts may be broken or missing.
7—For parts only or major restoration.

Mechanical Condition Scale
A—New. Apparently working correctly.
B—Apparently working.
C—Working, but accuracy of shutter (especially at slow speeds) questionable.
D—Not working.

Lens Condition Scale
i—New. Apparently unused.
ii—Clean and clear, minor

handling marks.
iii—Optics require cleaning/ cloudy.
iv—Signs of fungal growth.
v—Signs of lens separation.
vi—Major damage or defects.

Whatever scale is used by a dealer from whom you are considering making a purchase, remember that all scales are subjective. Ask as many questions as needed to clarify all the terms to your complete satisfaction.

7
TESTING A CAMERA

Examining a camera before purchase is similar to a detective looking for evidence at a crime scene. An eye for details and knowledge of camera functions can help reveal the condition of a camera. You can learn if it was repaired and if it was tenderly used or severely abused by the previous owner. A little extra time examining a used camera can be well worth the effort and may even save you some money in the long run.

A little extra time examining a used camera can be well worth the effort.

If a camera is damaged, you'll need to consider repair. There is no doubt that any camera can be repaired if spare parts are available. If parts are not available, skilled machinists can even manufacture replica parts from scratch. You must decide if a particular camera is worth the money and effort, and then find a skilled restorer. For most cameras, you will find that repair and restoration are not worth the expense and effort. Generally, restoration is best reserved for historically important cameras. For other cameras, replacement is more cost-effective.

When buying a used camera for personal use, we generally want to consume the least amount of money possible to get a product that meets our needs. Think of used cameras as items that can be tossed away or sold when they break down. Most cameras, even expensive ones, are disposable when the cost of a major repair is considered.

A crucial step in evaluating any used photographic item to determine its worth and utility is checking the major functions of the equipment. This involves many different parts that need to be inspected for both functionality as well as physical condition. A machine, a skilled technician or you yourself should complete all of the following tests before any money or equipment changes hands.

■ SHUTTER TESTING
Shutter Testing Machines. Many camera repair shops have shutter testing machines that accurately measure the actual exposure time for each setting on the shutter speed dial. From this information, a skilled technician can deduce what (if anything) needs to be done to return the shutter to top work-

ing order. In many mechanical shutters, the mechanism that operates long exposure settings is separate from the short exposure device. It is common for one shutter speed range to function normally, only to have the other shutter speed range jam open. For many buyers, the ability of a camera's shutter to synchronize with electronic flash is critical. Most shutter testing machines can test for flash synchronization.

Manual Shutter Testing. Unfortunately, camera shops and used camera dealers rarely own shutter testing machines. If they did, undoubtedly some customers would insist that every new and used camera under consideration for purchase be tested until a "perfect" camera could be found. Perfect cameras are rare. Shutter testing machines would therefore impede timely business transactions in most camera stores.

Camera manufacturers build shutters to operate within an acceptable range of performance rather than exactly hitting each shutter speed on the button. This is possible because of the exposure latitude of most films and the wide latitude of photo processing materials, equipment and operators. Focal plane and leaf shutters that operate within 10% of their stated speed are operating normally. Remember that shutter exposure times double as they get longer, i.e., a 1/500th of a second exposure is twice as long as a 1/1000th of a second exposure. Therefore, a 10% variation from 1/1000th of a second is a small amount.

For some mechanisms, like old or dirty leaf shutters, the speed will change dramatically with every exposure. This is not normal. All focal plane and leaf shutters must be cleaned and adjusted occasionally to maintain reliable operation.

Given the wide range of acceptable shutter operation, camera buyers do not need complex testing machines to assure themselves that the camera they are considering purchasing is functioning correctly. It is merely necessary to open the back of the camera, point the camera at a light or a blank white wall and try every shutter setting. By looking through the back of the camera, it is easy to see if the shutter curtain opens properly and to guess if the exposure times are close to accurate. This test is easiest with the slow

Camera buyers do not need complex testing machines.

speeds, such as 1, 1/4th or 1/30th of a second. If the shutter curtain jams open or travels at varying speeds during exposure, the mechanism needs work. Short shutter speeds are more difficult to assess. Testing the accuracy of the high est settings requires a shutter testing machine. Manual shutter tests serves to confirm that the shutter curtain will open properly during operation.

Shutter curtains and the blades of leaf shutters should also be inspected for wear, dirt, rust, holes, bending, and fingerprints.

Another test of shutter curtain function is how evenly it moves as it passes across the film. At speeds above 1/60th of a second, many 35mm camera shutters do not open fully during

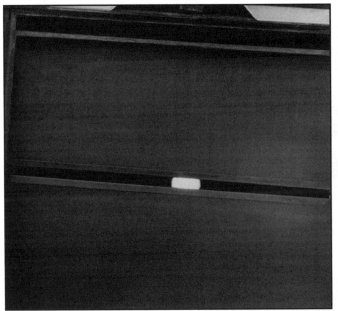 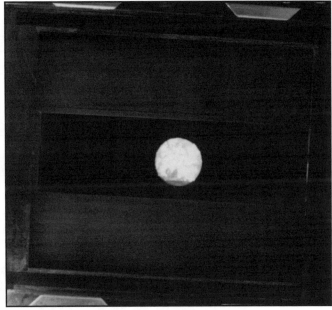

These two pictures of a Speed Graphic focal plane shutter illustrates how the width of the opening in the shutter can vary with the selected shutter speed. The left picture is the 1/500th of a second setting, while the photo on the right is about 1/125th of a second. At both settings, it takes the shutter about 1/10th of a second for the opening to travel over the full negative. But because the slot size changes, the effective exposure time changes. Photos by David Arndt.

exposure. Instead, a open slot will travel across the film exposing the emulsion as it passes. The width of the slot varies with the selected shutter speed. The faster the shutter speed, the narrower the slot. If the shutter changes speed during exposure, the density of the picture will also change. This results in vertical or horizontal stripes in the picture. The orientation of the stripes depends on the direction of shutter travel. A uniform subject is needed to detect this problem. Try photographing a white wall or a clear blue sky.

A uniform subject is needed to detect this problem.

■ LENS APERTURE

While you have the back of the camera open, this is an excellent opportunity to check the aperture in the lens. The first thing to do is to set the shutter speed to B (for Bulb) and press the shutter release button. Continue to hold the release button down and look through the open shutter curtain as you are aiming the camera towards a white wall or light source. With your free hand, reach around the camera and find the aperture ring. Move the ring back and forth several times, going from the lowest setting to the highest setting. The aperture leafs should open and close easily and with no hesitation in the motion. If the aperture leafs are slow in responding (lagging behind your movement of the ring), then there is a good possibility that the lens may need repair.

Another method for checking the aperture is to set the camera shutter speed to one second and the f-stop (aperture) to its highest setting (usually either f-22 or f-32). Next, look through the shutter curtain while the camera is still aimed at the white wall or light source and then press the shutter release button. When the

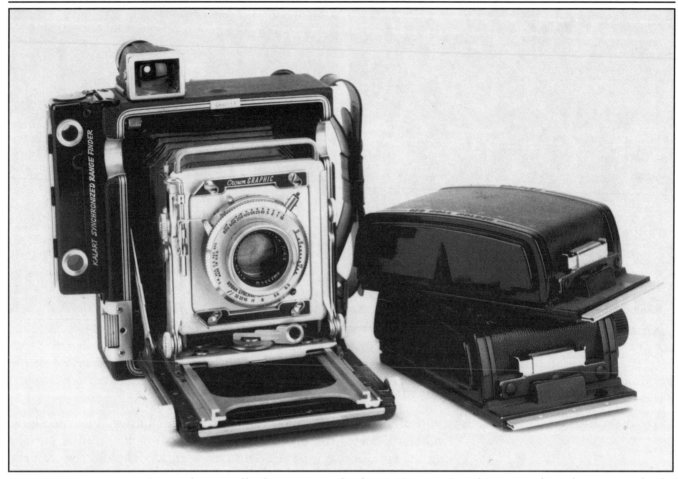

This is a Crown Graphic with two roll film accessory backs. A Crown Graphic uses a leaf shutter inside the lens. The focal plane shutter used in the Speed Graphic was deleted from the Crown Graphic. Not all Speed and Crown Graphic cameras shot 4x5 inch film. Photo courtesy of Christie's South Kensington Ltd.

aperture is not working properly, you will see the leafs move into and/or out of position. This hesitation is usually caused by the presence of grease on the leafs. When the aperture is working properly, you will not see the movement; rather, you will only see the leafs in their closed position.

■ **FLASH SYNCHRONIZATION**
When photography was in its infancy, photographers used magnesium flash powder to create the light necessary for making good exposures. This material smoked up a room and could start fires. Shortly after this period, flash bulbs became the predominant method for artificially lighting the photographer's sub-

ject. But even their usefulness was short-lived. Electronic flash slowly replaced flash bulbs in the 1960s. Today, new flash bulbs are no longer available.

The duration of light from an electronic flash varies between 1/1000th and 1/100,000th of a second. It is necessary for the shutter to completely open over the entire piece of film before the flash is triggered (otherwise the frame would be unevenly exposed, with light from the flash hitting only part of the frame). The shutter speed at which this happens is called the flash

This material smoked up a room and could start fires.

synchronization speed. The speed varies from model to model, but the most common speeds for focal plane shutters are between 1/30th and 1/250th of a second. Leaf shutters built since the introduction of electronic flash usually synchronize at all speeds.

As opposed to electronic flash, flash bulbs emitted light over much longer periods, so synchronization times were different. Some camera models have flash cord connections labeled F (fast synchronization speed) and M (medium synchronization speed). These connections timed exposure to match the moment of the maximum light output of the flash bulb. Some flash bulbs burned so slowly that photographers triggered the flash, which then tripped a solenoid that triggered the camera shutter. This method was popular on the 4"x5" negative press cameras built from the 1930s to 1950s.

Look for overlapping pictures or uneven spacing between the images.

■ FILM ADVANCE

Shooting a test roll and examining the negatives is the best way to reveal any film advance problems. Look for overlapping pictures or uneven spacing between the images and broken sprocket holes. If you can't shoot a test roll, examine the function of the film advance mechanism with the camera back open. It should function smoothly and continuously without skipping.

■ FOCUS

To test the focus of both manual focus and autofocus cameras, mount the camera on a tripod and aim at a complex test subject like a flat brick wall or a lens test chart (a sample test chart follows on page 40). Focus and shoot a test roll of film. Use the slowest film available and the widest aperture possible ($f1.2$, $f1.4$, $f1.8$ or $f2.0$). This will keep the depth of field, or the zone of focus, very narrow. Examine the resulting pictures, and, if they are not very sharp, you should either have the camera repaired, or don't buy the camera at all.

■ EXPOSURE METER OR AUTO-EXPOSURE

While you are testing the focusing capabilities and resolution of a potential camera or lens, use the same film and procedure to test the exposure meter or the auto-exposure system. Be careful to select a subject without bright whites or dark blacks. Because meters are designed to produce an accurate exposure on "average" subjects, too much black or white in an image will fool even the best meter system.

If you are uncertain about a test subject, purchase an 18% gray card. Place the gray card in the same light as the subject of the photograph). Fill your viewfinder with the gray card and take an exposure reading. Light meters are generally calibrated with the assumption that the "average" scene reflects 18% of the light that hits it. Metering from an 18% gray card will therefore give you an accurate reading for the scene. If you don't have a gray card, you'll find that green grass is also very close to 18%.

When your film comes back, if there is a problem with the exposure, your prints will either be

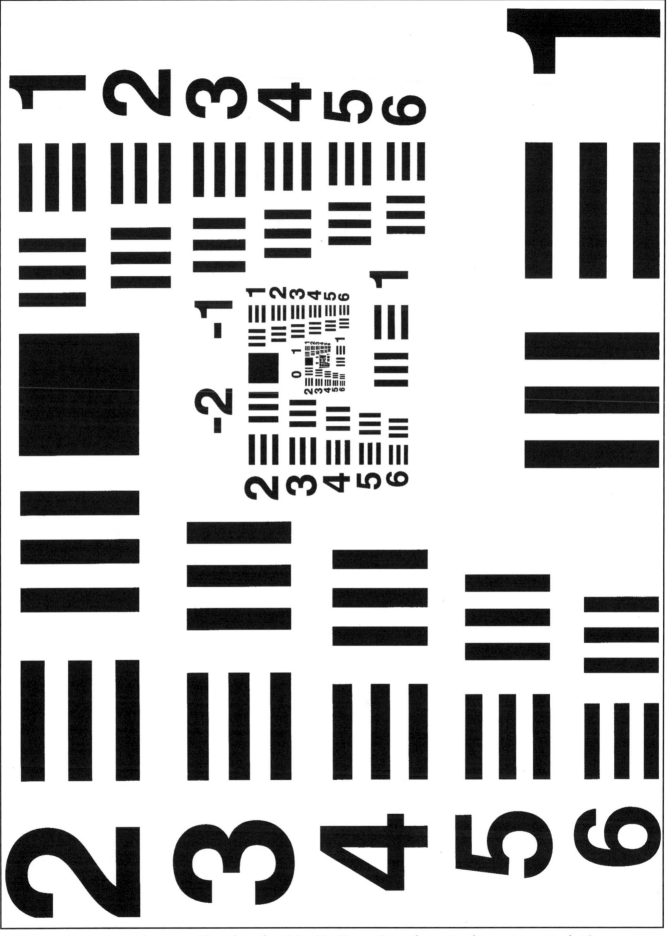

This is an optical test chart attributed to the U.S. Air Force. It makes a good target to test the focus or resolution of a lens. A copy of the chart is available from many photography sites on the Internet. Better camera dealers sell other test charts that work just as well.

darker or lighter than the scene actually appeared. Repairs can be expensive, so if the meter or auto-exposure function doesn't function properly you may wish to look for another camera.

■ LENS BELLOWS

Some modern cameras and many classics use lens bellows. These pleated square tubes of black rubberized or plastic fabric suffer a lot of stress on the corner of each pleat. Sometimes the coating or the fabric fails, allowing unwanted light to leak in. The simple way to test for leaky bellows is to shoot a long exposure and process the picture. Light leaks will appear as white blotches similar to the ones seen in the photograph (below) of a Kodak camera.

To test for leaky bellows, shoot a long exposure.

■ LIGHT LEAKS

Most modern cameras do not have fabric bellows. If these cameras exhibit fogged film (film with spots, streaks, etc.) check the gasket material between the camera and the back. If the foam that seals the gap between a camera body and a camera back is compressed, damaged or missing (as in this picture), light could leak in and fog the film. Replacing the gasket foam is an easy repair for most technicians.

Cracks in plastic camera parts could also cause this problem, as will pinholes in shutter curtains. When examining a camera, be sure to check carefully for cracks and other damage that could result in light leaks.

To test for the existence of light leaks in non-bellows cameras, load it with film and place it in

The Toyo view camera used to photograph this Kodak 126 film camera had several pin size holes in the bellows folds. White blotches made by leaking light appear in a line from the center to the upper left corner. The blotches prove there are pinholes in the bellows of the Toyo view camera used to make this picture. The camera store promptly returned the purchase price when shown this picture. Photo by David Arndt.

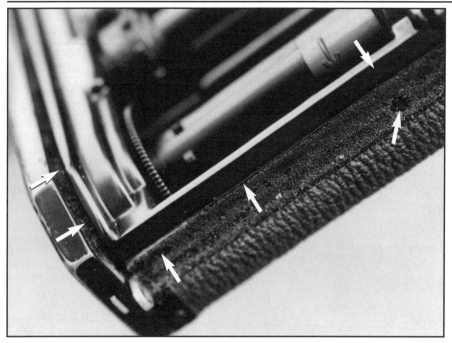

If the foam that seals the gap between a camera body and a camera back is compressed, damaged or missing (as indicated by the arrows in this picture), light could leak in and fog the film. Replacing the gasket foam is an easy repair for most technicians. Photo by David Arndt.

direct sunlight for a few minutes. Then advance the film and let the sun hit the other side of the camera. Process the film and examine the negatives.

■ BODY CONDITION

A cautious buyer will inspect a camera or lens carefully before making an offer. Check the following for condition clues.

Chipped Bakelite. Bakelite is a form of plastic that was used in cameras from the 1920's through the 1960's. The material becomes brittle with age and cracks and chips easily. Use extreme caution when handling these antiques. Cameras with Bakelite are collectible not only as cameras but also as Bakelite antiques. A Bakelite camera may only be worth $10 to a camera collector, but the same camera might be worth $25 to $30 to an antique dealer who collects Bakelite items.

Dents. Dented camera parts disfigure the camera and lower its value but may or may not impact the mechanism's performance.

Leatherette Covering. Work on the decorative leather or fabric cover that many companies use to decorate camera bodies is a good indicator of a camera repair. Technicians must often peel back the covering to access screws that hold the body components together. After the repair, the cover must be re-glued. If the new glue fails, the fabric will lift and curl. A loose, split or curling cover is a reliable clue that indicates a repair of some sort.

A loose, split or curling cover indicates a repair.

■ MISSING PARTS

Abused cameras may be missing parts like screws, retaining rings and rubber grips. Avoid such

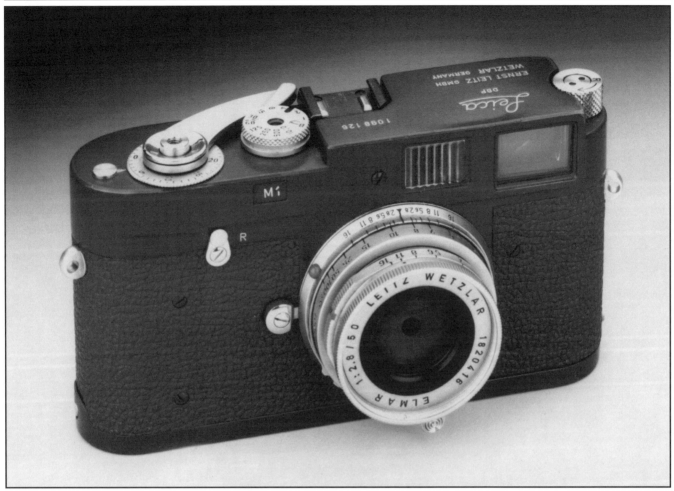

(Top) This Leica M1 has a large dent on top near the Leica name and the viewfinder window. This dent might have damaged the delicate rangefinder mechanism and could affect its accuracy. Photo courtesy of Christie's South Kensington.

(Right) Note how the leatherette covering on this camera has been torn from the body. A skilled repair technician can re-glue the covering or replace it completely. The color and texture of the replacement is likely to be different from the rest of the coverings on the camera. Photo by David Arndt.

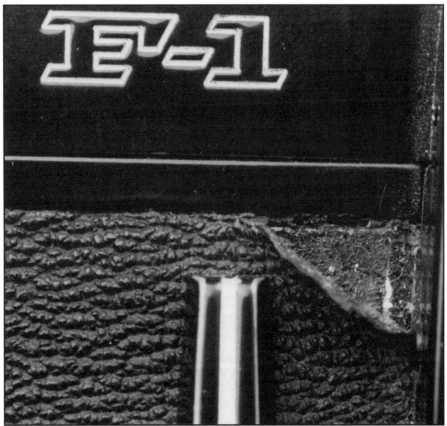

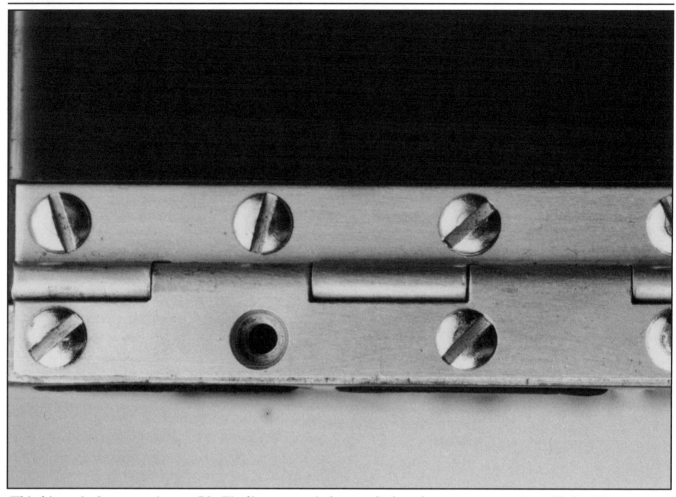

This hinge is from an Argus C3. Finding a precisely matched replacement screw is unlikely. Most camera repair technicians would take a screw off an identical C3 that is used for replacement parts and add it to the customer's unit. Photo by David Arndt.

equipment as hopeless causes, unless parts are still available from the maker or if you have a second version of the same model to use as a parts camera.

■ LOOSE PARTS

It is very common for parts to work their way loose due to heavy use.

The Minolta SRT101 mentioned in a previous chapter suffered from a worn lens mount that reduced the sharpness of the pictures it made. Sometimes the twisting and turning of a neck strap will cause the mounting post to become loose. Fixing this problem involves cracking the camera open and tightening the bolt.

When testing a camera, shake it gently and listen carefully. If you hear a rattle, a part has broken loose inside; walk away from this camera.

This situation is similar to that of a student in an automobile engine repair class that has re-assembled a Ford V8 motor and got it running. He asks his teacher, "What do I do with all these extra engine parts?" The motor, just like the camera with a "rattle," might run now

It might run now but its long term prospects are poor.

but its long term prospects are understandably poor.

■ MIRRORS

Single Lens Reflex (SLR) cameras use a mirror to reflect the light from the lens into the viewfinder. During the exposure, the mirror must move up and out of the light path before the shutter can expose the film. The silver coating on the mirror is on the front of the glass and therefore is very delicate and easily damaged. Inspect the coat-

Inspect the coating for scratches, and inspect the mirror glass for chipping.

ing for scratches, and inspect the mirror glass for chipping. Do not touch the front of the mirror with your finger or cotton swabs because you could remove the silver coating. If the mirror surface needs cleaning beyond what a lens brush can do, have a professional repair shop do the cleaning. Specialized materials and techniques must be used to prevent damage.

■ MIRROR CUSHIONING FOAM

A thin strip of black foam normally cushions the mirror. If this foam strip is damaged or missing, the camera must be repaired. Some buyers that would notice

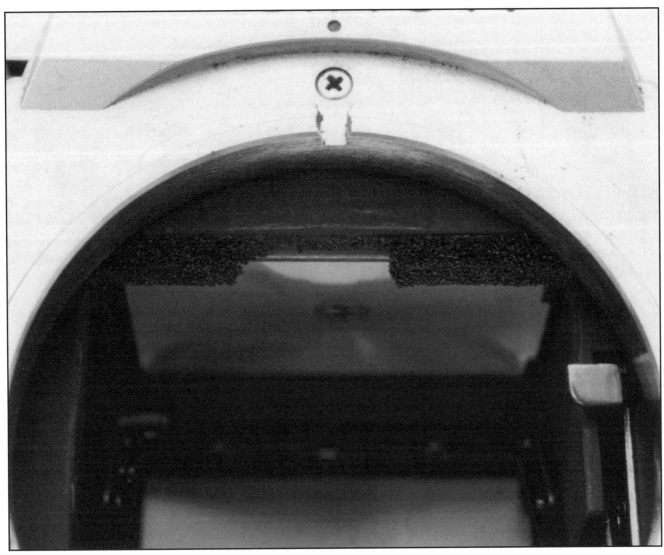

This camera is missing part of the mirror's foam cushion. Photo by David Arndt.

The black paint has been worn off of the edges of this Canon F1 Prism. Missing paint only affects the resale value and not camera function. Missing paint is, however, a good indicator that the mechanical features of the camera need to be carefully checked. Photo by David Arndt.

that part of the foam was missing or loose would not notice if it is completely gone. Removing the foam completely in order to fool a buyer is obviously unethical.

■ MISSING PAINT
Paint scratches happen even with normal use. Light or moderate amounts of scratching are nothing to worry about, but a heavily scratched paint job can be a warning flag that indicates hard use. Modern cameras might have a black plastic body or a metal electroplating over a plastic body. They resist scratches much better than paint. They are a vast improvement over their delicate predecessors. Polycarbonate plastic bodies are often more durable than metal bodies because they are more resilient. The black parts are black all the way through, so a scratch will only show more black plastic.

■ BATTERY AVAILABILITY
In 1994, the U.S. Congress banned the use of mercury in batteries. This killed the popular PX13, PX625 and other batter-

ies. Many fine cameras made in the 1960s, '70s and '80s used these batteries. The Duracell PX625A and the Varta V625U are sold as replacements. The original PX13 was rated at 1.35 volts and held that voltage until it died. Unfortunately, while the replacements start their life with voltages as high as 1.8 volts, as they age the voltage drops as low as 0.9 volts before their charges are depleted. Because accurate light meter operation depends on a stable voltage output, the unstable output of the replacements is a problem. As a result of this drop in voltage, the accuracy of the exposure changes with battery age. There is no good way to work around this problem. When considering buying a camera that uses a PX 13, PX625 or similar battery, remember that consistent exposures will be a problem.

While you are looking inside the battery compartment, check also for corrosion and damage from leaking batteries. This can damage electrical connections and circuit boards. A leaking battery changes the voltage output of the entire battery pack, which can also damage electronic parts.

The unstable output of the replacements is a problem.

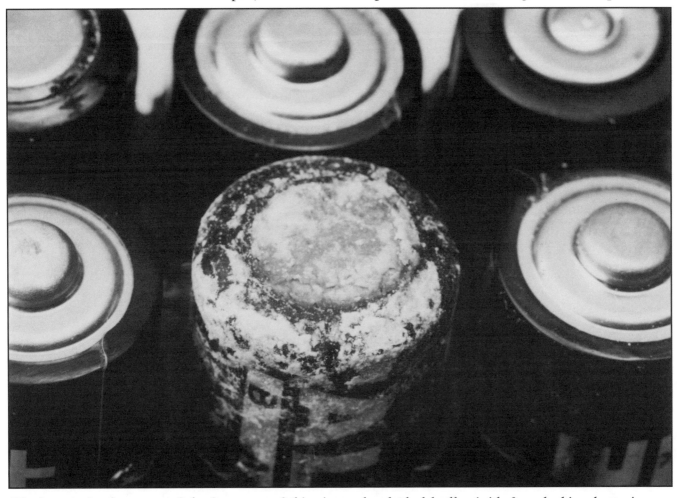

The battery in the center of the front row of this picture has leaked badly. Acids from leaking batteries can corrode electrical connections and circuit boards. A leaking battery changes the voltage output of the entire battery pack, which can also damage electronic parts. These batteries were taken from an electronic flash. Photo by David Arndt.

■ LENSES

The open camera test is also used to test the operation of the lens iris. Select a slow shutter speed and test each lens setting. Look to see if the iris opens a different amount for each setting. Never disassemble a lens to oil the iris. Oil migrates to cover the lens surface and the entire lens mechanism. Visible oil on an iris or a leaf shutter may mean an amateur repair attempt. A bent leaf in a shutter or iris is another sign of trouble. Lens and camera repair should be left to experienced camera repair people. Specialized tools and lubrication materials are needed for proper repair.

De-cemented Elements. Most lenses have combinations of glass elements that are glued together with special transparent glues. Sometimes this glue fails, resulting in a foggy appearance in the lens. It can be seen by looking through a lens held up to light. Lens technicians can fix this problem by cleaning and re-gluing the glass. With proper repair, the lens should work as good as new.

Dented Filter Ring. A dented filter ring, usually the result of a lens falling and landing on the front edge, could mean the lens elements have been knocked out

Dented filter rings generally result from a lens falling and landing on the front edge. The impact probably was strong enough to dislodge the delicate alignment of the internal optical parts. Realigning these glass elements requires expensive specialized tools. Test the lens carefully before purchase. Don't pay a premium price for these lenses. Photo by David Arndt.

of their delicate alignment. At the very least, damage to these rings can prevent the use of screw-on filters.

Don't pay a premium price for lenses with damage like this, and don't neglect to test the lens thoroughly.

If you decide to purchase, a lens vice can gently and easily push a dent back into correct position. However, misuse of a lens vise can distort the lens barrel, make focusing rough on manual focus lenses and prevent proper operation of auto-focus lenses. Lens vises and other repair tools are available through several mail-order companies who advertise in photography magazines. Unless you are an experienced technician (or have limitless funds for trial and error), you may want to leave this repair to a professional.

Misuse of a lens vise can distort the lens barrel.

Dirt. Dirt on a front or rear surface of a lens is easily removed with a soft brush or compressed air, but dirt inside a lens requires complete disassembly and cleaning. Worse yet, internal dirt may jam the aperture, autofocus mechanism or even a leaf shutter. Sand is difficult to keep out of a lens and expensive to remove. Fortunately, most owners take better care of their lenses than they do their camera bodies. As a result, lenses are normally safe purchases.

Lens Fungus. Lenses in humid parts of the world may suffer from growth of fungus. Fungus can etch the glass and thereby ruin the lens.

Lens scratches. A few small scratches on the front element of most lenses do not impair performance significantly. The reason is that depth of field works in your favor. Except for macro lenses and super wide-angle lenses, the scratches are far out of focus when the picture is made. Large numbers of tiny scratches will reduce the contrast of a lens and severe scratching will add a fuzzy look to back-it subjects.

However, the buyer should be extremely aware of scratches of the rear element of the lens. While the depth of field works in your favor when there are scratches on the front element, it will work against you on the rear element. Because there is less distance between the damage and the film, every nick and ding will show on your picture. Avoid buying a lens with this type of damage.

As always, there are exceptions to this advice. If the rest of the lens is in excellent shape and you are able to buy the lens cheaply enough to be able to afford replacing the rear element, go ahead and make the purchase.

Autofocus Function. Some autofocus lenses and cameras require occasional re-calibration as a normal part of everyday use. Consider this an ordinary part of owning a high tech camera. If you find a problem with a camera's autofocus, consult with a trained technician to determine whether re-calibration may be an appropriate and effective solution.

■ VIEWFINDERS

Even with normal use, viewfinders are dirt collectors. Finger-

prints cover the outside surfaces, and dust gets trapped in the viewfinder cavity. Periodic cleaning will keep such accumulations from causing other problems. If a dirty viewfinder is the camera's only problem, it can usually be cleaned up easily.

■ RANGEFINDERS

Rangefinders are a subcategory of viewfinders. A tiny mirror inside the rangefinder superimposes a tiny section of the image over the primary image. When the two images overlap perfectly, the picture is in focus.

The delicate mirror mechanism can be damaged several ways, thereby changing the accuracy of the alignment mechanism. The mirror might shift up or down, get dirty or broken, or the silvering on the mirror might wear off. Worn silver may be possible to spot upon a physical examination of the camera. Shooting a test roll is the best way to determine whether or not the alignment mechanism is functioning properly.

■ DIGITAL CAMERAS

Digital cameras should be checked for all the applicable functions listed earlier. The appropriate software, cables and user's manuals must be included in the deal. Some of the common cable connections include serial, USB and FireWire. Sellers should either demonstrate the camera with a Windows 95 or Macintosh computer, or allow prospective buyers to test the camera with their personal computer.

Examine the digital image for the presence of interference which appears in the form of unwanted or dead pixels. A failing microchip may generate an image that shows tearing or it might have missing pixels.

Most digital cameras offer removable flash memory cards to store the photographs until they are downloaded into a computer. For a digital camera to be useful, these cards (which come in several formats) must be widely available and also compatible with your computer set-up.

Digital camera technology improves regularly, so the value of used digital equipment drops rapidly. Eventually, some of the earliest digital cameras will be so severely obsolete that the cables and the software will no longer be compatible with modern computers. Obviously, this knowledge must be factored into your digital camera purchase.

Most digital cameras offer removable flash memory cards.

■ ACCESSORIES

Some camera collectors are willing to pay extra if cameras and lenses still have their original cases, caps, instructions and boxes. Some professional photographers throw these items away so that they don't interfere with easy camera operation. The value you place on these items is your decision.

(Top) The owner of this Argus camera chose to cut his initials into the leather case to prove ownership. Even with this damage, the case improves the value of the Argus because the product is more complete. Photo by David Arndt.

(Right) The seller of this camera outfit carefully preserved the boxes and user manuals for many years. The preservation of the accessories increased the auction price he received when he sold the merchandise a few years ago. Photo courtesy of Christie's, South Kensington Ltd.

CAMERA EXAMINATION CHECKLIST

- **Accessories**
 - ____Case
 - ____Miscellaneous papers
 - ____Neck strap
 - ____Original box
 - ____Owner's manual
 - ____Warranty card
- **Body condition**
 - ____Battery compartment damage
 - ____Chipped Bakelite
 - ____Chrome scratches
 - ____Cracks
 - ____Dents
 - ____Leatherette cover
 - ____Loose parts
 - ____Paint scratches
- **Film compartment**
 - ____All parts present
 - ____All parts working
 - ____Cleanliness
- **Lens bellows**
 - ____Cracks
 - ____Pinholes
 - ____Rips
- **Lens**
 - ____Aperture function
 - ____Case or box
 - ____De-cemented elements
 - ____Dented filter ring
 - ____Dirt
 - ____Focus
 - ____Lens cap
 - ____Lens fungus
 - ____Missing parts
 - ____Scratches on front element
 - ____Scratches on back element

- **Mirror**
 - ____Dirt
 - ____Mirror condition
 - ____Mirror cushion foam
 - ____Mirror operation
- **Rangefinder function**
 - ____Accuracy
 - ____Dirt
 - ____Mirror condition
- **Shutter**
 - ____Auto exposure
 - ____Film advance
 - ____Film rewind
 - ____Flash synchronization
 - ____High shutter speeds
 - ____Low shutter speeds
 - ____Shutter curtain condition
- **Viewfinder optics**
 - ____Chipped or cracked glass
 - ____Dirt
- **Test film roll results**
 - ____Auto exposure function
 - ____Autofocus function
 - ____Film advance and rewind function
 - ____Flash synchronization
 - ____Light leaks
 - ____Rangefinder accuracy
 - ____Shutter function
 - ____Uniform exposure
- **Digital cameras**
 - ____Software present
 - ____User manuals present
 - ____Compatible cables
 - ____Internal memory or memory cards present or available
 - ____Image tear
 - ____Interference
 - ____Speckles
 - ____Dead pixels

8
THE LAW

■ RETURN AND REFUND POLICIES

Most camera retailers post their used camera return and refund policy. Some even print it on their invoices and cash register receipts. Retailers tend to be scrupulous about following posted guidelines because they don't want to anger their customers. They know that angry buyers can quickly spread negative opinions throughout a community. Photographic communities are small, even in big cities, and a bad reputation can ruin a business.

Each state regulates consumers' return and refund rights. If you are unsure what the laws are in your state, consult your state consumer affairs (or consumer protection) office for guidelines.

Each state regulates consumers' return and refund rights.

A few camera dealers choose to ignore local laws, restricting return and refund rights beyond what is allowed by law. Retailers might not know the law, or they may choose to ignore it and take the risk of an unhappy buyer filing a formal complaint over a used camera. This is often a safe bet on their part because, with few exceptions, the costs of a lawsuit are greater than the value of the camera.

To protect yourself, consider consulting your local Better Business Bureau or consumer affairs board to research a dealer from whom you are considering making an expensive purchase. These organizations keep records of complaints filed by consumers. If you notice a dealer has been the target of numerous consumer complaints, this is probably a good indicator to look for another dealer from whom to make your purchase.

If no return or refund policy is clearly provided by the dealer, ask for one in writing. Finally, always retain all paperwork associated with the purchase (even if the camera seems to be working right now, some existing problems may take a while to reveal themselves). Paying by check or credit card (rather than cash) offers another level of protection in the event of problems.

■ STOLEN EQUIPMENT

When buying used photographic equipment, there is always some danger of acquiring goods

which were not acquired legally (although neither you or the dealer may know).

In an effort to help recover stolen good and return them to their rightful owners, police departments circulate descriptions and serial numbers of stolen cameras and photographic equipment to dealers, known collectors and pawnshops. Surprisingly, this method works quite often.

Fortunately, the possibility of accidentally buying stolen cameras is extremely small when dealing with established businesses. The probability is much higher when you are approached by strangers and offered equipment at bargain prices.

As far as legal matters are concerned, the best way to protect yourself and your money is to buy from a reputable source. Ask questions, do your homework, and keep concise records. If problems occur, you will be happy you took the extra time to do so.

9
WHERE TO BUY AND SELL

There are a wide variety of sources from which to purchase used cameras. Some are good, some are not so good. A few common types of dealers are listed below.

■ LOCAL CAMERA STORES

Local camera stores are generally the safest place to buy a used camera because they depend on repeat business to survive. However, they are the least profitable places to sell your used camera.

Local camera stores offer the great advantage of having the item available for you to test and inspect. A buyer can shoot a roll of film with the camera or lens and evaluate the results before making a purchase. Local camera stores also tend to employ knowledgeable sales people who can help you make smart choices to match your needs with the right equipment.

Additionally, a local dealer will often dicker with a buyer and may lower the asking price or include an accessory to sweeten the deal. This negotiation is unlikely to happen with mail order firms or Internet auction houses, where prices tend to be set in stone.

The price camera shops pay for used equipment varies little from store to store. "At Warehouse Photographic, customers that choose to sell their cameras on a consignment basis earn 70% of the final sales price and Warehouse Photographic takes a 30% commission. As long as the customer doesn't need the money that day, this process permits a better return for them. When we buy equipment, we offer 25% of the used value," says Ed Sandbach, Professional Products Manager for Warehouse Photographic and Lab in Carrollton, Texas.

"Individuals thinking about buying and selling used cameras as a business should be aware that when a customer wants to sell equipment that day, there is a good possibility that there is something wrong with the equipment. Because we offer a 30 day warranty on used equipment, we don't pay the seller until that 30 day period is over," Sandbach continues.

Knowledgeable sales people can help you make smart choices.

"We have three regular used camera dealers that sell us cameras. One in particular has made a living traveling to pawn shops around the country. He buys the right equipment, brings it to us and sells it on consignment at our store. From time to time, you hear about somebody getting a good deal at a pawn shop, so you rush out and can't find anything worth buying. This one particular gentleman has an agreement with a lot of pawnshops to hold the stuff for him. He just buys the whole lot from them. He does bring us sought-after equipment in clean condition and delivers them in clear plastic containers. This way, if we don't have room in the display case, we can stack them up in storage and safely keep them in neat condition," say Sandbach.

"When he started this, he asked a lot of questions to educate himself about what he needed to get and what the values were. We only see him every three or four months, and he brings us maybe a hundred pieces at a time. The other two guys who operate in this manner bring us less favorable equipment," Sandbach concludes.

Depending on the marketability, good used equipment will sell for 60 to 70 percent of the new price, reports Sandbach. The store inspects and tests the cameras before placing them on sale. "We test on 1/500, 1/60 and one second settings to make sure they are what they appear to be," he said.

■ MAIL ORDER

Mail order houses draw customers from around the United States and Canada. With such a vast market to draw on, disappointing or angering an occasional customer is not as damaging a problem as it could be for a local camera shop. But magazine publishers who accept advertisements from the mail order establishments often enforce a code of standards for these businesses to meet. Publishers will investigate any complaint against a mail order merchant and attempt to negotiate a settlement of the dispute. The mail order business complies voluntarily because it is good business to treat customers fairly. In extreme cases of repeated complaints from several readers, the magazine might stop publishing the merchant's ads.

The big mail order houses often provide benefits no other merchant can match. The most important benefit is providing access to rare cameras and hard-to-find accessories. Searching for a rare lens or an obscure camera or accessory is very easy when all one has to do is sit back in a recliner, read the ad and place a telephone call.

Local camera dealers frequently complain about the tough competition they get from the big mail order dealers. The locals claim the mail order houses sell new cameras for less than the price local dealers pay wholesale for the cameras. Sales tax collection is also a sore point for local retailers. Some states try to collect local sales taxes on interstate mail purchases, others don't. States that don't collect sales taxes on mail orders give mail order dealers an advantage over local dealers. Saving a

Mail order dealers almost always charge for shipping.

six percent sales tax on a $1,000 purchase is a $60 advantage.

On the other hand, mail order dealers almost always charge for shipping and handling so the savings from sales tax is often effectively negated. A careful buyer might find that when she adds in all the purchase expenses, mail order is just as expensive as buying locally.

Savvy consumers should also note that the possible savings from mail order houses are often limited to the camera, and does not extend to pricing on the accessories. Mail order dealers may offer the camera body at a loss to attract the customer. Once the customer has committed to the camera, their hope is that she will also purchase their more profitable accessories such as filters, lenses, flashes, tripods and darkroom supplies.

If there is one prime advantage of mail order, it is that the big dealers' sales volumes are so high that they can afford to stock a wider variety of items than most local stores. Local stores can special order any item from any product line they carry, but the mail order firm might get the item to you faster if you are in a rush.

You cannot personally examine the equipment before buying.

If there is one prime disadvantage to mail order, it is that you cannot personally examine the equipment before buying and often don't have the benefit of the knowledge of an experienced sales staff. A dirty trick that camera buyers play on local camera stores is to examine and test a camera or lens locally and then mail order the item to save a few dollars. This is not an ethical way to go about purchasing equipment. Employing knowledgeable sales help is expensive, and local camera shops deserve to be paid for providing this vital service.

■ USED CAMERA SHOWS

Another fine place to buy used photographic equipment is through a weekend camera show. Vendors feature used cameras and accessories, darkroom equipment and supplies, and new and used books. An occasional computer is offered, and sometimes even film is sold.

Dealers at these shows offer a wide variety of equipment choices and an opportunity for inspection and testing. Shooting a test roll of film with a camera you want to buy is more difficult because these shows are short term events. Test film must be taken to a one hour mini-lab to get timely results.

Bargains are rare at camera shows because professional dealers study a variety of authoritative sources to learn the probable sale price for each item in their inventory. Occasionally, an amateur collector buys table space at a show just to thin out a collection. Big bargains are possible in these cases if a buyer arrives early before the best items are sold. If you find an item you want, feel free to make a very low offer. The worst that will happen is that the dealers will make a counter offer.

Donald Puckett has been hosting camera shows in Texas, New Mexico, and Oklahoma since 1985. His son Todd joined the

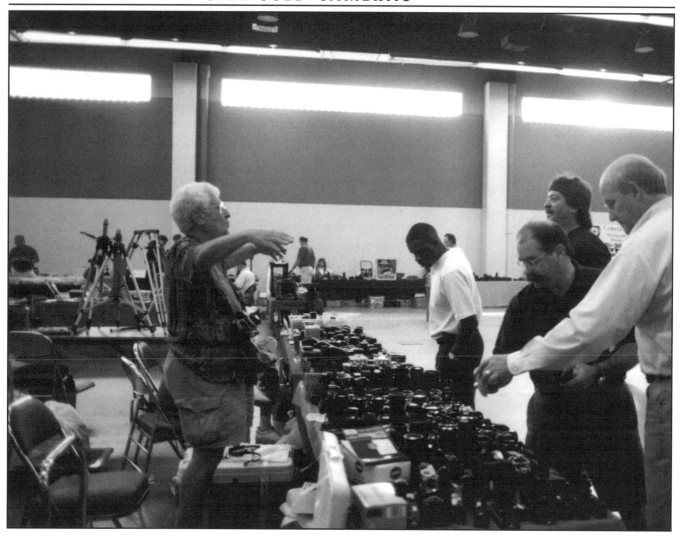

Sometimes the discussions and price negotiations at a camera show can get very animated. Photo by David Arndt.

family business in 1997. In 1999, they hosted a dozen shows. Each show is open to the public Saturdays and Sundays.

"The smallest shows have around thirty vendors, the large shows have over ninety," Todd Puckett says. "The smallest show we have is forty tables, and the largest show is about 130 tables. One year we had 155 tables. I guess the largest sponsor of camera shows is Sam Vinegar, out of Michigan. He'll put on one or two shows the same weekend in the Midwest and on the East Coast. Gary Chapman puts on camera shows in St. Louis,

Kansas City and Omaha. He'll do St. Louis and Kansas City about four times a year, and he'll do Omaha about once a year. In Florida, Nancy Green does shows in Florida, Alabama, Georgia, and New Orleans," Puckett says.

"A lot of the vendors at the shows have normal jobs and do these shows on the weekends. Another large group of them own camera stores, and they attend camera shows to buy and sell equipment. And then there are the weekend warriors who only get a table or two in a show whenever they run across stuff to sell. Occasionally, we will have as

many as fifteen tables where individuals want to clear out their personal inventory. They don't want to sell their stuff to one person at a loss. They want to get as much as they can, so we encourage them to get a table," he says.

Renting a table runs between $40 and $150, depending on the show and the sponsor. The sponsors generally do not take a percentage of the sales. Instead, their income generally comes from table rental and from the sale of admission tickets. Sales tax is another issue that must be con-

sidered by exhibitors. "In New Orleans, the state comes around and collects the sales tax at the beginning of each day. They ask how much you think you're going to sell, and collect the estimated sales tax in advance." Puckett says.

Attendance at Puckett's six shows in the Dallas-Fort Worth region averages between 800 and 1,100 people. "The good news is that the local camera stores use the sales to build up their retail store traffic. They use the camera shows to promote their stores. For the amount of money that

Attendance at weekend camera shows peaks Saturday morning when the most choices are available. This picture was made on a Sunday afternoon. In two days, this show drew about 900 people who paid five dollars each for admission. With a widely available coupon, the price dropped to four dollars each. Photo by David Arndt.

they spend and for the number of people that come through, that is the most efficient way of hitting their target market," Todd Puckett reports. "For about a month after each show, we will have people who come in and say, 'I saw you at the show and thought I'd come over to check out the rest of your inventory.'"

During slack times at the shows, dealers wander around and check out what the other dealers are offering and what prices they charge. Dealers freely buy and sell to each other. One national chain rents tables at the Dallas area shows, but does more buying than selling. This keeps the inventory in their used camera department fresh and ever changing. "The chain representative bragged that he bought twice as much equipment as he sold," Puckett recalls.

Most of the buyers at camera shows, however, buy the equipment to use, not to collect and resell. "Colleges and high schools who give photography classes encourage students to go to camera shows, not necessarily to buy anything but just to look around to see what is out there. For a lot of people, this is a good way to build their system up. Then, once they are better photographers or have more money, they can move up to better cameras and just sort of grow into it. We had one guy who went out and spent thousands of dollars on the best stuff because he wanted to take the best pictures. He didn't realize that it is the photographer behind the camera that makes the good photo and the good print," Todd Puckett says.

"There are very few problems with cameras sold at the shows not functioning the way the should. First of all, anybody that has had a problem has come up to us and said this guy did whatever he supposedly did. We will go to that guy and tell him or her the problem we have heard about. If it is because of them, then they fix it; otherwise, they won't be coming back to our shows. I don't want people going in with the thought they could get stuck with something. Then people won't come to the show because they'll think it's a gamble," says Puckett.

Used camera shows happen several times per year in most larger cities and are generally held at a conference center, hotel or other venue. Most are advertised locally in newspapers and other media. You can also keep your eyes open for a sign at your local camera store, or ask at store as to whether they have heard of an upcoming show or know when they are generally held.

For a lot of people, this is a good way to build their system up.

■ AUCTIONS

Auctions are generally of two types and have two different functions. The first type of auction is designed for the rapid disposal of merchandise when maximizing the price is not important. Estate sales and tax auctions are examples of this type of auction. The second type of auction, conducted by specialty auction houses, can maximize the price received for an item or group of items. Specialty auction houses concentrate on finding high quality or rare merchandise with-

A very expensive item, like this Canon autofocus 400mm f2.8 lens, can be purchased at a more reasonable price at an auction. Photo courtesy of Canon USA.

in a category and selling those items to collectors.

Any adult can participate in an auction. Nearly every auction requires participants to pre-register before the sale. This usually involves either providing the auction house with a credit card number and an address or proof of a bank line of credit. The auction house will verify the information before the auction starts. No one who fails to pre-register is allowed to bid.

Items at auctions are either offered in groups called lots, or sold individually. For example, an estate auctioneer may insist on selling all the camera equipment together so that the auction moves on to other items quickly. When items are sold in lots, you might have to by fifty pieces of junk to get one jewel. Sometimes a camera may be sold all by itself. The choice is up to the auction company.

Before the auction date, a list of items for sale is circulated to interested bidders or advertised in newspapers or trade magazines. Some auction houses print elaborate catalogs that are pro-

Cameras and Optical Toys

Christie's South Kensington
Thursday 31 August 1995 at 10.30 a.m. and 2.00 p.m.

CHRISTIE'S

This French-made Enjalvert Revolver Camera graced the cover of Christie's auction catalog of cameras and optical toys. It sold for $86,357 (£55,750) at an Christie's auction in August 1995. Photo courtesy of Christie's South Kensington Ltd.

vided or sold to known clients and prospective clients a month before the auction. On auction day, bidders have the opportunity to inspect and possibly handle the merchandise before the sale.

■ SPECIALTY AUCTION HOUSES

Most auction houses will sell an occasional camera, but few specialize in cameras. Several sources report that the leading place for camera auctions is London. Several English auction houses

hold regularly scheduled camera and photographic equipment sales. The most famous of these businesses is Christie's South Kensington Ltd., a company which is widely renowned for selling the most expensive fine art and antique furniture. They also sell cameras and photographic accessories to clients worldwide from their South Kensington location. Another European auction house that sells historical cameras is the

Dorotheum in Vienna, Austria, founded in 1707 by Emperor Joseph 1.

The leading American camera auction house is Tamarkin Photographic equipment <http://www. tamarkin.com>. Based in Connecticut, the company has held auctions in New York City, Chicago, Tucson and Denver. The firm held its first auction in 1996. Commissions at Tamarkin range from 10 to 11.73 percent for the seller. The buyer's fee is ten percent of the sale price. Prospective sellers may use the company's free appraisal service to set the reserve price. A reserve price is the minimum price the seller will accept. Tamarkin, like most other auction houses, publishes illustrated catalogs that it sells to prospective buyers. The

company posts the results of each auction on its website for the world to see.

Christie's first photographic sales were held were in 1972. "In 1977, we set the world auction price for any camera at £21,000 pounds. We hold the current record price for any camera at £55,750. That camera was an Enjalvert Revolver Camera (pictured on the opposite page), which was made in France in 1882. It looks very much like a revolver," Christie's camera expert and Associate Director Michael Pritchard reports.

Cameras sold at a Christie's auction do not need to be unique or historical. "We find that collectors are looking to buy across price ranges, from literally $100

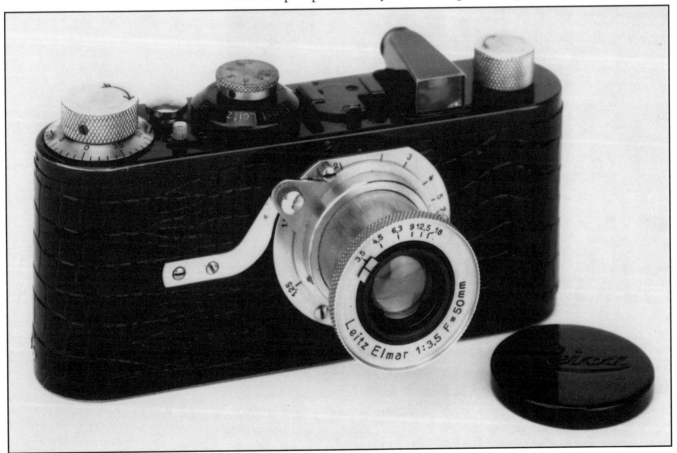

Leica cameras, like the model A pictured here, and other Leica accessories are extremely popular items at auctions. Photo courtesy of Christie's, South Kensington Ltd.

upward. What we have found recently is that collectors are being a bit more discerning when buying in terms of the condition and the working order of the camera. This is because a lot of these cameras that we sell, even the pre-war Leicas, for example, are being sold for use. People want to use these cameras. The nice things about cameras, in fact, is they are not just things to put on display. Collectors want to use them even if they are an 1850's plate camera or a roll film box camera," Pritchard reports. There is also some activity from museums purchasing cameras for their collections. "The museums are selective about what they are buying because they are collecting for specific reasons," Pritchard said.

Selling with an auction house like Christie's is not just a matter of sending them your camera and getting a check back. "The first

Used and antique camera auctions sometimes include one-of-a-kind prototype cameras such as this Kodak Brownie Target, which reportedly was made when Kodak was considering licensing the Mickey Mouse character from the Walt Disney Company. The camera was never put into production. Photo courtesy of Christie's South Kensington Ltd.

Collectors sometimes have esoteric tastes. This wooden Voightlander camera prototype for the Vitessa 500 and 1000 was sold at a Christie's auction. Prototypes from Leica, Nikon and others are sold from time to time. Photo courtesy of Christie's South Kensington Ltd.

thing that a person looking to sell a piece or just looking to have an evaluation is to contact me either by e-mail, phone or fax. What I would then do is to give them a provisional auction estimate based on their description and maybe a photograph of the object. Then if they decide that they would like to consign it, they would FedEx or send the camera to me in London. Once I actually see the object, we would send you a receipt and put it into one of the specialist camera auctions that we hold. There is a minimum two month lead time between the arrival of the camera in London and the auction. This allows for production and distribution of the catalog," he says.

"There is a relatively small group of people that are interested in 19th century cameras, like the traditional mahogany and brass cameras. The strongest section of the market is basically post-1920 cameras probably using 35mm 120 or 127 roll film. They might be box cameras, roll film folding cameras or precision cameras. The reason for this is that they are cameras people can still obtain film for. People do actually want to use these cameras, even if they are just putting one roll of film through. Within that,

a bit deeper, there are certain cameras, like Zeiss Contrarex cameras for example, that are very sought after. They must date from the 1960s and early 1970s. In a way, they were the ultimate 35mm cameras. Stereo cameras are also sought after. There is a very strong demand for spy and sub-miniature and disguise cameras, too," Pritchard says.

Pritchard also says that there is also a market for early technical manuals, photographically illustrated books, first edition Leica manuals from 1936 and books on miniature cameras. "There is little interest in darkroom equipment built after 1870, with the exception of timers, light meters and some of the magnesium flash guns."

A subscription to the Christie's camera auction catalog is $85 per year for nine issues, and their website is located at <www.christies.com>.

■ LOCAL AUCTIONS

Cameras sometimes are sold at regional and local auction houses. If you develop a relationship with your community auction company, the staff will notify you when cameras come up for sale. Sometimes an auction house will purchase a newspaper ad that lists every major item to be auctioned on a particular day. The list may be long and disorgan-

Spy cameras are not limited to Minox products. Many cameras were disguised as cigarette packages. Typically, these cameras would use 16mm movie film. Photo courtesy of Christie's South Kensington Ltd.

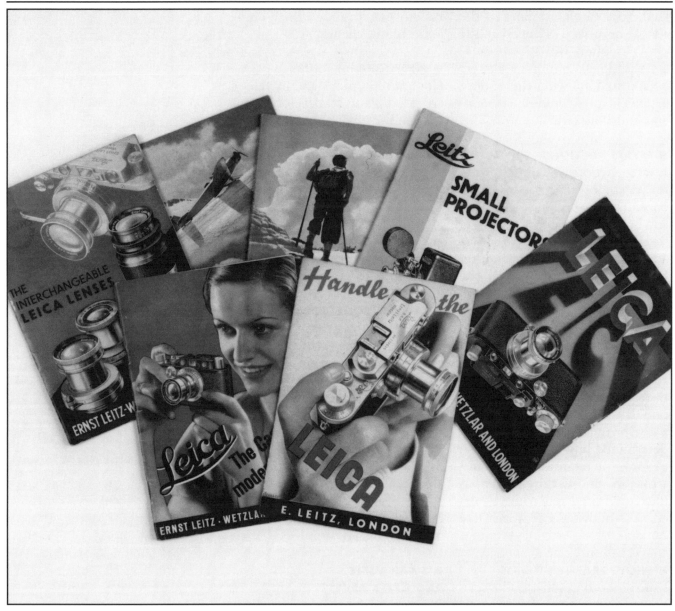

(Top) Some Leicaphiles also collect the manuals and Leica magazines. Photo courtesy of Christie's South Kensington Ltd.

(Right) This Polaroid J66 might come up for sale at an auction. Before biding on a camera, check to see if film is still available. Polaroid no longer makes film for this camera, Photo by David Arndt.

ized, so a careful reading of the ad is necessary. However, the effort is often worth it because an occasional gem of a camera gets mixed in with the endless supply of point and shoot cameras and Polaroids.

■ ESTATE AUCTIONS

Estate auctions occur following the death of a person who has considerable holdings that are left behind with no one wishing to claim them. To settle the will and quickly convert the household property into cash, the executors will ask an auction company to sell everything in one day. This emphasis on speed gives the camera buyer an advantage. Each lot in this sort of an auction must sell very quickly if the sale is to be completed in just one day. Rapid sales might mean a low price and a bargain for the determined buyer. You may wish to look for estates of physicians, attorneys and wealthy people, as they are more likely to have purchased high-priced items like cameras.

■ PHOTOGRAPHY STUDIOS

Failed photography studios can be good places to find bargains. If a photographer is carrying a heavy debt load and needs cash fast, bargains can be found. Bargains are especially good for photographic accessories such as lighting systems, darkroom equipment and studio props. These items are expensive new but hard to sell used because other portrait and wedding photography studios already have most of what they need.

The best way to locate these bargains is to network with area professional photographers and processing laboratories. People like to gossip about their competitors and clients.

■ PHOTOGRAPHY CLUBS

Community photography clubs are good places to develop a reputation for buying used cameras. Some photographers trade their camera for a new one every few years. A member with a camera to sell is likely to offer it to an acquaintance before trading it in at the local camera shop. Many clubs also post notices of sales and meetings on bulletin boards in the lobbies of photo labs.

■ CAMERA COLLECTORS

Camera buffs that have an Internet service can use it to locate the national club devoted to their preferred camera maker or model. No accurate listing of each club is available because web sites change their Universal Resource Locator (URL) address from time to time. The national club can generally guide buyers to the nearest local chapter, who hold regularly scheduled local meetings.

■ SWAP MEETS AND FLEA MARKETS

Bargain hunters flock to swap meets and flea markets looking for deals. Buyers hope to find a bargain and buy it far below the going price. For this plan to work, extreme patience is needed. Many weekends spent looking for just the right camera bargain might be necessary. Another factor is that buyers must have an accurate sense of the market value of the camera or lens sought. The third element is that the dealer must be ignorant of the value of

Bargain hunters flock to swap meets and flea markets.

the item he is selling. Few professional flea market dealers will be ignorant of the value of their primary merchandise specialty.

More likely, a bargain will be found when a specialist in other products like toys or porcelain dolls will sell a camera just to get rid of it. The camera might be part of an auction lot or an estate they purchased just to get items in their specialty. Don't assume, however, that they are ignorant of the value of the cameras they sell. They may read the books and magazines listed later in this book.

Don't be afraid to offer the dealer a very low price.

Don't be afraid to offer the dealer a very low price for the camera. They might accept. The very worst that will happen is the dealer will make a counter offer. As always, knowledge is power. In the struggle between buyer and seller, the one with the best knowledge about the merchandise usually wins.

■ FRIENDS

Depending on the individual, friends and family can be a very good or very bad group to deal with in regards to used cameras.

Individual sellers in general frequently overvalue the camera because of its family history or because they remember how much they paid for it. Also, if you buy the camera for a low price and then make a big profit from reselling it, their feelings might be hurt if you don't share the rewards with them. On the other hand, if they buy a used camera from you, you might be asked to teach them how to use it or fix it every time something goes wrong with it.

On the other hand, as noted in chapter three, if a friend or family member is planning to get rid of a camera model you are looking for, you might be able to make a good deal. Whenever buying from friends or family, keep the seller's personality and knowledge of cameras in mind and make your decisions accordingly. Obviously, it's not worth jeopardizing a personal relationship over a used camera.

■ GARAGE SALES

Garage sales are fun, and used cameras are almost never priced correctly. On the other hand, the chances of finding a used Leica or Nikon are miniscule. Professional level cameras at garage sales are as rare as hen's teeth. A good way to find a bargain camera at a garage sale is to read the classified. They are listed under yard sale, garage sale or moving sale. If you find a camera listed that interests you, call the people holding the sale and try to view the camera the night before the sale. If the ad only includes an address and not a phone number, use the internet or your local library to search for the number. If you can't reach the seller by telephone, arrive at the sale before the listed start time and inspect the camera as the sale is set up.

■ CLASSIFIED ADS

The classified advertising sections of newspapers are divided by topic. This helps readers find the items they need. Metropolitan newspapers frequently list items for sale in the photography and camera categories every day. Sunday classified sections normally have the biggest selection.

Cameras & Supplies L-7

Digital Cameras

RICOH digital cameras $500 each ███████████

Bronica SQAI system with flash & tamrac case $3,500 ████████████ or e-mail ████████ for list

Basic darkroom setup Omega Color enlarger $750
★★★★ ██████████ ★★★★

Kreonite 20in color paper processor; Pako B-C Eight photo lab equip ████████

NIKON6000 w/prof.105 2.8 macro lens & spec. ring & point light ███████

████ buys good clean used Photo equip ████████

I buy good clean used photo equip. ████████.

Canon AE1 $195 Minolta SRT102 $150 ████████

Pentax 6x7, 165mm 2.8 lens $1250 ████████.

This listing of newspaper camera ads is typical of what is listed in Sunday newspapers across America.

Some papers publish an early Sunday edition that hits the newsstands midday Saturday. This is the best edition to buy.

Most newspapers print the Sunday classified newspapers sections a day or two early. This evens-out the work load on the printing press crew. Sometimes the newspaper will also sell you the classified section early. If the front desk clerk won't sell the section early, you might try going to the loading dock and asking the press crew for a copy. Newspaper home delivery carriers often get the classified sections a day early. If

Be prepared to pay extra for the service.

yours does, ask if he or she will deliver the section to you as soon as it arrives. Be prepared to pay extra for the service, as news carriers don't work for free and are always poorly paid.

■ INTERNET

Classifieds and Direct Sales. Many newspapers have their own Websites where they post all their classified advertisements. These classified ads include cameras and photography studios that are for sale. The ads are often posted a day ahead of publication. Call your local paper to obtain its website address. Camera stores, collectors, sellers, and buyers also post their offerings (and the items they are looking for as well)

Lots of bargain lenses are found in the used equipment market. Photo courtesy of Christie's South Kensington Ltd.

on their own web pages. More than a dozen search engines are available to help locate web pages devoted to the camera of your choice.

Local camera shops were quick to seize on the commercial potential of the Internet. Hundreds of camera shops list their used equipment on their web pages. It is an inexpensive way to reach an international audience. Internet customers could be 2,000 miles away or across town.

Camera shops are normally careful to provide accurate descriptions of the items and truthful condition reports in order to protect their reputations. Internet chat rooms and discussion groups have a reputation for being quick to condemn a retailer for their sins. When this happens, it is possible for thousands of potential customers to learn about the incident. Before taking such condemnations as gospel, though, remember that retailers have no defense against false accusations and no recourse when it happens on the Internet. A few Internet users will make false claims just to stir up trouble and try to get a reaction from the merchant.

Internet Auctions. Many established camera stores use on-line auction services to sell slow moving equipment. Because the stores use their real name, address and phone numbers, fraud is unlikely. Individuals can also auction a camera or photographic accessory through various on-line companies. The seller provides the auction service with a description and photograph of the item to be sold, noting the minimum sale price. The service then posts a special web page for the item and allows bidders several days to make offers. The service will list the highest bid to date so other bidders have the option to bid higher. The web auction services collects a percentage of the sale price from the seller and it is the responsibility of the seller to ship the item promptly to the buyer. Dishonest patrons that don't complete their portion of the deal are banned from future use of the service.

Ebay.com was the leading web auction service in 1999. The number of clients using the service at the same time was once so high that the computers running the system crashed for many hours. Ebay.com expanded the number of clients it can handle, and relatively few complaints about the service have since been reported.

E-bay offers several types of auctions and provides ample tutorials on each for new users. In addition, you can access a database of information regarding to the experiences of other buyers who have made purchases from an individual selling an item you are interested in buying. This can help you learn if the seller's description is likely to be accurate, and how quick they are to ship purchased items. While Ebay.com does not guarantee their merchandise, they do sell insurance that will compensate buyers for certain problems such as non-delivery of merchandise or merchandise not being as described. E-bay also closely monitors both sellers and buyers to eliminate

E-bay also closely monitors both sellers and buyers.

fraud and provide an environment that is safe and reliable for consumers.

In 1999, Amazon.com expanded its own service from on-line book selling by adding on-line auctions. Amazon.com uses a system similar to that of Ebay.com, but they have not built up a camera sales section to equal that of Ebay. As of mid-1999, Amazon.com offers buyers a limited guarantee of a maximum $250 refund if the seller fails to meet certain performance standards. Since guarantees are subject to revision, the details are left to the service and will not be reviewed in this book.

One user and advocate of Ebay.com is amateur photographer Russell J. McGuire of Dallas, Texas. McGuire successfully bid $400 for a 25 year old Bronica S medium format camera that came with a 90mm wide angle lens, a 150mm normal lens, three 120 size film backs, six filters and a camera bag. He said the equipment arrived seven or eight days after he won the bid and sent the seller the check. McGuire also won a bid on a Saunders/LPL enlarger with polycontrast filters, for which he bid $100. "The one problem with E-bay is that these brown boxes keep showing up on the porch. My wife gets home first and I can't hide my purchases from her," McGuire joked.

Internet auctions are a wonderful way to sell cameras but a more risky way to buy cameras.

Internet auctions are a wonderful way to sell cameras but a more risky way to buy cameras. Sellers are safe because they do not have to ship the merchandise until they have the money in hand. On the other hand, it is very easy for con-artists to advertise, sell, and collect money for merchandise they do not have.

An indication of the rising problem with Internet auction fraud is shown in a report from the United States Federal Trade Commission (FTC) released in September 1999. The FTC received only 300 complaints about Internet auction fraud in the first six months of 1998; it received over 6,000 complaints in the same period of 1999. Attorney Generals in several states have begun prosecuting several of these cases. Most of the fraud incidents occur when individuals who use pseudonyms to hide their identity try to defraud unwitting customers.

While Internet auction companies do not accept responsibility for the crimes of the con-artists, they do sell services designed to protect consumers from fraud. Some offer insurance policies that pay off if the equipment is not delivered. Other auctions sell an escrow service, where an independent company holds the buyers payment until the equipment is delivered. Neither service is used often because people buying from auction sites are bargain hunters and are generally resistant to adding to the expense.

One famous case involved a person that used the pseudonym "Kuchar1." Kuchar1 offered for sale several Olympus digital cameras. He used several different auction sites at the same time. The winning bidders sent Kuchar1 their credit card infor-

This Olympus camera is similar to the camera auctioned in Kuchar1's famous Internet auction fraud case. Photo courtesy of Olympus.

mation, including their name and address. Kuchar1 charged the bid price to the buyer's credit card. Kuchar1 then applied for and received a credit card in that person's name but had the card sent to a different address. Kuchar1 then used the new credit card to buy a new version of the camera from a different on-line service that shipped it to the buyer. The winning bidder lost by paying for the same camera twice.

Cases of Internet fraud should be reported to your local police department as well as the United States Federal Bureau of Investigation <http://www.fbi.gov>, The FTC <http://www.ftc.gov/ftc/complaint.htm>, the United States Postal Inspection Service, <http://www.usps.gov/websites/depart/inspect/>, and the National Fraud Information Center <http://www.fraud.org>.

Newsgroups. Another Internet service is newsgroups. These are text-based discussion groups. Thousand of newsgroups are active, and most web browsers can connect and search the listing for groups dedicated to specific subjects such as cameras and photo collectibles. Members of these chat groups often trade or sell cameras amongst themselves. The URL's for newsgroups change rapidly, so none are listed in this book.

10 PRICING

■ **RESOURCES**

Before shopping for a lens or accessory, a buyer should know precisely what they want and what price is being asked nationally. The reverse is true for sellers. Both parties can refer to the standard industry references.

"My customers usually check prices through *Shutterbug* magazine and books such as *McBroom's Camera Bluebook* or any of several other price guides. *McBroom's* is probably the best because it not only gives prices on camera bodies but lenses and accessories as well," says Todd Puckett, used camera shop operator and used camera show host. "McKeown's *Price Guide to Antique and Classic Cameras* covers the old antiques."

Professional camera dealers use *McBroom's Camera Bluebook* and *The Trader's Edge*, a periodical that tracks about 15,000 used camera and accessory prices by region. Anyone can buy a copy directly from the publisher, but the $90 price for two issues effectively limits readership to professional dealers and very serious collectors. Copies can be ordered from Katydid Publishing by mail or on-line at <www.mugjoint. com/katy-did/order.html>. The publication consists entirely of lists of average prices sorted by product category and regions of the Unites States. The publisher depends on voluntary reports from subscribers.

McBroom's Camera Bluebook is the most widely available reference. It can be purchased at better camera shops or read at public libraries. Author Michael McBroom limits the book's listings and articles to the recent cameras and better camera choices for actual use. Other books specialize on older and classic cameras or a particular brand.

Some of the reference books on pricing include (in alphabetical order):

■ *Lind's List Camera Price Guide and Master Data Catalog 1999-2000*. Lind, Barbara (editor), James M. McKeown, and Joan C. McKeown. (Amphoto, 1999).

> **Professional camera dealers use *McBroom's Camera Bluebook* and *The Trader's Edge*.**

- *McBroom's Camera Bluebook: A Complete Up-To-Date Price and Buyer's Guide for New & Used Cameras, Lenses, and Accessories.* Michael McBroom. Amherst Media, 2000.
- *Price Guide to Antique and Classic Cameras 1999-2000.* James M. McKeown, Joan C. McKeown. Centennial Photo Service, 2000.
- *The Traders Edge.* Katydid Publications

Many highly specialized books are privately published (often by camera organizations or collectors) and are hard to find. The best bet is to search the Internet or contact one of the specialty camera collectors clubs for help in locating a particular edition. For example, there are several Leica identification and price guidebooks. There are also guides available for many other camera manufacturers and camera lines. For more information, contact the club devoted to collecting in your particular area of interest. Many of these groups maintain web pages. Another good source for locating these groups is the Directory of Associations, which is available at many public and college libraries.

Shutterbug magazine sells advertisements to dealers that publish long lists of used and new equipment for sale. To determine an average retail price for a camera, such as last year's Minolta, requires readers to inspect every ad, record every condition report and price for the camera, and then compute an average.

Remember that magazine publishing involves a long lead time. Several weeks might pass between the day a finished ad is delivered to the publisher and the day you read it. So a bargain priced camera might already be sold out by the time you call the merchant.

■ RETAILER VS. HOBBYIST VALUATION

Retailers value cameras differently than most used camera buyers.

Most sellers look at their merchandise more like a financier judges an investment. Sellers know how much they paid for an item, when they bought the item, it's average resale value and the price they need to sell it for to make a profit. Some dealers will consider the interest that is charged on the line of credit they used to buy the camera. If an item takes too long to sell, the interest expense builds until selling the camera merely for the going price results in a loss. As a result, some dealers carefully track how long an item has been in inventory and will cut the price in order to sell it before he loses money on the sale.

Buyers tend to include an emotional element in their used camera buying decision. Sometimes the emotion is nostalgia for a similar camera once owned many years ago. The purchase may be driven by a desire to own a product the buyer could not afford at one time. Some people get caught up in the manufacturer's emotional advertising message, which combines messages about sex, love, prestige and the quality of pictures that the user can create with a particular product.

Buyers tend to include an emotional element in their used camera buying decision.

A buyer who purchases a camera the day it arrives in the used camera store will pay a much higher price than if she has the courage to wait a month or two, or even six months. Buyers must find their personal comfort zone and balance their desire for an item with the risk of someone else buying it.

Fortunately, buying a camera for use is easier than collecting rare cameras. Good used cameras of recent vintage are relatively plentiful and easy to find in almost every make, model and price range. Antique cameras, on the other hand (and especially those in good condition) are relatively more rare.

11 RESTORATION AND REPAIR

■ RESTORATION OF ANTIQUES

With most antiques, cleaning and restoring an item will lower its value. Fans of *The Antiques Roadshow* television program often see experts tell people that because they cleaned dirt and grime off of a 200 year old dresser, its value has dropped by thousands (often tens of thousands) or dollars. Part of the reason for this is that the antique industry is flooded with fakes. The amount of dirt, grime, and wear and tear found on each item is one of the important clues used in detecting fakes. Furniture, for example, is easily and inexpensively copied, but the duplication of dirt and grime is very difficult.

Unlike most antiques, repairing and restoring used and antique cameras may increase the unit's value. However, there are signs that buyers of extremely old cameras are beginning to prefer units that have not been fixed. The value of cameras made during or after the Great Depression is presently enhanced by mechanical and cosmetic restoration. Restoration of obsolete cameras may backfire should the collector/hobbyist ever follow the mainstream antique market's preference for dirty and damaged cameras.

"The advice I usually give clients who are thinking about consigning material is to leave it exactly in the condition that it is in and allow the potential purchaser to make the decision of whether to clean or repair the mechanics of it. That is usually the best course of action to take in terms of helping the seller get the best possible price. Potential buyers normally like to do any work themselves and not see something that is freshly cleaned and has had work done which they may or may not agree with. The best advice is usually to leave it exactly as it is," says Michael Pritchard, camera expert and Associate Director of Christie's South Kensington, Ltd., an a leading auction house for cameras and photographic equipment.

> **Allow the potential purchaser to make the decision of whether to clean or repair.**

■ AVAILABILITY OF PARTS

Ted Bannai has more than twenty years experience repairing

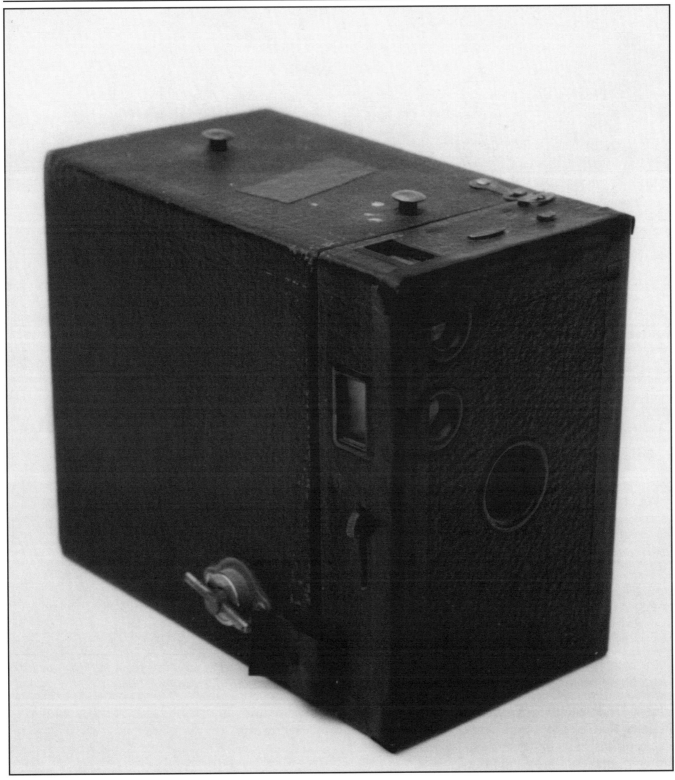

The owner of this Kodak Brownie 2A model B box camera (circa 1917) tried to make it functional by using electrical tape. The residue from the tape probably ruined the original paper covering and ultimately made restoration economically unwise. The camera needs 116 film, which is no longer available. Photo by David Arndt.

A few camera technicians specialize in converting the fine Kodak Medalist II cameras from 620 film to 120 film, thereby making the camera usable. Photo courtesy of Christie's South Kensington Ltd.

cameras and selling them at flea markets across the southwest. He cautions buyers that most camera makers stop selling replacement parts just two or three years after a model has been discontinued. For this reason (among others) many camera repair shops limit their work to cameras and equipment for which parts are available directly from the manufacturer or importer. More often than not, they perform only warranty work.

Because parts go out of production so quickly, repair shops which deal in older cameras are often forced to strip parts from other cameras just to provide a spare part. Repairing new automobiles with used parts is frowned on in many situations,

but used camera parts are the only choice for many camera models. Some parts needed to repair used and antique cameras must even be hand made. Therefore, restoration can be very expensive.

■ MODEL CHARACTERISTICS

Bannai says that each model has its own characteristic problems that occur regularly. For example, the Canon AE1 develops a squeaky mirror box when the lubricant dries out. If a Nikon EM has a jumpy light meter needle, then the unit needs an overhaul. Bannai repairs sixty percent of the cameras he sells before placing them on display for sale, and he offers a six-month guarantee on used cameras. Bannai reports he buys used cameras for 35 - 40% of the anticipated resale value.

Repair might make economic sense for cameras if film is still available.

Before selecting a camera brand or model, discuss the choices with used camera specialists to learn the drawbacks of each model. This is a good way to avoid any recurring problems (and costly repairs) that could outweigh the pleasure gained from photography.

■ FILM AVAILABILITY

Since most used cameras are sold to be used, restoration or repair might make economic sense for cameras if film is still available. Kodak still makes film in the following formats: 4x5, 5x7, 8x10, 135, 120, 220, 70mm, 110 and APS. A few mail order dealers will take 120 film and spool it on to 620 film cores for customers. A few obscure film sizes such as 127 are still made in Europe.

■ RESTORATION VS. RESALE VALUE

Ultimately, the key to making an informed repair or restoration decision is to balance the cost of the work against the resale value of the unit. Cleaning and adjusting an Argus C3 for $95 is a poor idea when its resale value is between $10 and $50. At the other end of the scale, restoring a rare or one-of-a-kind camera often makes sense in view of resale prices reaching into thousands of dollars. Emotional, family or historic factors may also play a role in your decision on whether or not to repair.

■ FINDING REPAIR AND RESTORATION SERVICES

Businesses that specialize in repairing specific brands of cameras and cosmetic restoration advertise in *Shutterbug* and other photography magazines. They can also be contacted via many of the same routes used to find used cameras in the first place. If your local camera store doesn't offer the service you need, ask if they can recommend someone. You may also find either technicians or good references to technicians by talking with vendors at a camera show. Finding collector groups which specialize in the model in question may also help lead you to a qualified repair person or restorer.

12 INSURANCE AND APPRAISAL

■ INSURANCE

Individually, most used cameras have little cash value, but a collection of cameras and accessories can represent a tidy sum. For this reason, camera owners should consider the benefits of insurance.

Amateur photographers' equipment is usually covered automatically under a homeowner's or a renter's insurance policy. These policies do a good job of compensating the owner for loss due to accident, theft, fire and some causes of water damage. However, insurance companies may require large collections or especially expensive equipment to be listed separately on the policy. They may also require an extra premium to insure the object.

Particularly valuable equipment should be photographed and the make, model, serial number, condition and value of each item must be recorded and stored in two or more different safe locations. This precaution is helpful if the insurance company challenges the existence of the equipment or its value. These records are also helpful in determining the cost of the insurance.

Professional photographers frequently insure their tools with a normal homeowner's or renter's policy. Professional photographers also need to buy a specialized policy called an Inland Marine policy (how the policy type came to be called Inland Marine is a mystery to me!) This type of policy protects the owner from losses that happen outside the owner's home.

Professional used camera dealers should also protect themselves by buying liability insurance. It is possible that the seller could be held responsible for damages and injures that happen while the photographer is using a camera. I once photographed a natural gas pipeline leak that happened at 1 a.m. Since flash photography was necessary to capture the picture, the El Dorado Fire Department was concerned that any electrical spark in the flash or inside the camera could ignite the natural gas. An explosion could have killed or injured many people. Fortunately, the flash did not ignite the gas.

Camera owners should consider the benefits of insurance.

Attorneys that prosecute personal injury cases pursue both a product's maker and retailer for failure to assure the product's safety, even in the most bizarre situations. Used camera dealers are not immune to this type of prosecution.

■ APPRAISAL

Sometimes insurance companies will request an independent evaluation of a camera's value before issuing insurance or paying a claim. The evaluation is called an appraisal. There are several professional societies of antique and art appraisers, as of this writing but no camera and photographic equipment specialty groups.

Accurate appraisals can be normally be obtained from used camera dealers, photographic collectors' groups and camera curators at the nearest museum that displays cameras. A list of such museums appears in Appendix I.

Insurance companies may request an independent evaluation of a camera's value.

With multiple published sources of camera prices, professional appraisal services are usually needed only for rare or historic cameras. Auction houses that specialize in used cameras will issue appraisals for potential buyers and sellers so they can have an estimate of the final selling price. But these appraisals are not guaranteed sale price points.

Stay clear of camera dealers and appraisers who make an appraisal and then offer to buy the unit at that price or lower. It is a good bet that the appraiser will take the camera and sell it for a big profit shortly thereafter. There are no groups or associations of professional camera appraisers. As a result, there is no code of ethics for camera appraisers and there is no accepted method of evaluating equipment and determining accurate values.

Appraising cameras is a valuable service that takes time, a high degree of knowledge and an investment in a reference library. Expect to pay a reasonable fee for a written appraisal. As a matter of courtesy, schedule an appointment with the appraiser so that their workday is not disrupted. Ask for a resume of their camera appraising experience to prove to the insurance company the appraiser's experience, skill and qualifications.

Some photographic collectors groups maintain web sites to share information and promote the group. Often, they post an e-mail address on the web page as a way to contact leading members. This is a good way to locate members who might be willing to perform an appraisal. There are dozens of free Internet search engines that are capable of locating websites of camera collectors. Each site often contains links to other related sites. Because these websites often change their web addresses, this book does not contain a listing of the collector clubs and their web sites. Such a list would be out of date before it could be published.

APPENDIX I
MUSEUMS

Few photographers can afford to spend $86,357 to own a one-of-a-kind camera, such as the Enjalvert Revolver Camera shown in Chapter 9. However, almost everyone can afford to visit a camera museum to admire or study such rarities. There are several of these kinds of museums, each with a unique collection devoted to different camera manufacturers or historical periods.

The International Photography Hall of Fame and Museum in Oklahoma City, Oklahoma is a good representative of museums that display cameras. Camera displays are an important part of the museum, which also has regularly scheduled short-term exhibits and a few permanently exhibited pictures. The International Photography Hall of Fame and Museum also functions as a hall of fame type of attraction. The Hall of Fame was founded in 1965 and honors photography's pioneers and leaders. By 1999, 49 people had been inducted into the Photography Hall of Fame.

The International Photography Hall of Fame and Museum's mission is "to promote public awareness and education regarding the innovators, technologies, arts and chronology of photographic imaging."

The museum began as a project of the Photographic Art and Science Foundation, which was created by the Professional Photographers of America. In 1977, the foundation decided to exhibit its collections as part of the University Museums at the Brooks Institute of Photography in Santa Barbara, California. In July 1985, the Museum and Hall of Fame moved into a 14,000 square foot segment of the Kirkpatrick Center in Oklahoma City. There are four galleries, where hundreds of cameras and several thousand pictures are part of the permanent collection. More than 500 photographers are represented in the collection.

In 1999, the museum was given the Brooks Photographic Research and Development Foundation camera collection that had been held by the Brooks School of Photography. Ernest H. Brooks, founder of the foundation also gave the museum a $400,000 financial endowment to further photog-

A grand mural and entrance invite people into the International Photography Hall of Fame and Museum in Oklahoma. The museum shares space with several other museums in the massive Kirkpatrick Center in Oklahoma City. Photo courtesy of the International Photography Hall of Fame and Museum.

raphy education and research. This museum now boasts one of the top camera collections in the United States. Other highlights include the famous photograph *Moon Over Hernandez, New Mexico* by Ansel Adams, and the world's largest photo mural—a 360° panorama of the Grand Canyon.

The following is a list of the world's leading public camera collections. Many museums have small collections, so you may wish to contact museums in your area, or in places you plan to visit.

■ Abring Foto Museum
Burg Horst, Haus Horst 1.
4300 Essen 14.
Germany

■ Agfa Foto Historama
Bischosgarten Strasse 1.
5000 Koln 1.
Germany.
<http://www.museenkoeln.de/museenkoeln.de/agfa/menu.htm> *(Site entirely in German.)*

■ The Canon company maintains a museum in Japan featuring every photographic item it ever produced. More impressive, however, is its web page which lists each item's productions dates, original prices (in Yen), a picture of the camera and its technical details <http://www.canon.co.jp/camera-museum>.

■ International Museum of Photography
George Eastman House
900 East Ave
Rochester, N.Y. 14607
<http://www.eastman.org>

This museum is based in the home of the late George Eastman, the founder of Eastman Kodak, and houses large collections of cameras and other examples of photographic technology. An 18th century camera obscura is the oldest item in the collection, which also includes cameras owned by famous photographers such as Joe Rosenthal, Ansel Adams, Eadweard Muybridge,

Arnold Newman, Alfred Stieglitz and Edward Weston. The museum also feature an extensive library and museum of photography ranging from historic to contemporary works.

■ International Photography Hall of Fame and Museum
2100 NE 52nd Street
Kirkpatrick Center
Oklahoma City, Oklahoma
<http://www.iphf.org>

■ Japan Camera and Optical Instrument Inspection and Testing Institute (JCII)
Ichiban-cho Building 25
Ichiban-cho
Chiyoda-ku
Tokyo 102, Japan
<http://www.nikon.co.jp/jcii>

The JCII Camera Museum opened in 1989 and displays historic, masterpiece and curio cameras from around the world (but especially from Japan). The museum has over 3,000 square feet of exhibit space, as well as a library, classrooms, rental darkrooms and a photo exhibit area.

■ Jersey Photographic Museum
Hotel de France
St. Saviour's Road
Jersey
Channel Islands
United Kingdom
JE2 7LA

■ Musee Francais de la Photographie
78 rue de Paris
91570 Bievres
France

■ Musee Suisse de L'Appareil Photographique
Ruelles des Anciens Fosses 6
CH-1800 Vevey
Switzerland

■ Museum fur Verhehr und Technik
Trebbiner Strasse 9
1000 Berlin 61
Germany

■ Museum voor Fotografie (Also called the Provincial Museum of Photography)
Waalse Kaie 47
B-2000 Antwerpen
Belgium
<http:/209.41.63.136/antwerp-fotografie.htm>

The museum uses photographs, equipment and documents to show the history of photography. Highlights include Dubroni cameras, an automatic stereoscope from 1903 and a portable developing cabinet.

■ National Museum of Photography, Film and Television
Pictureville
Bradford
United Kingdom
BD5 0TR
<http://www.nmpft.org.uk/guide/galleries/kodak/asp>
or
<http://www.nmsi.ac.uk/nmpft>

This museum features 100,000 objects and 150,000 images collected by Kodak Ltd. in England. The museum holds the world's first photographic negative, the original snapshot camera and the world's smallest working camera, which was made by Kodak for Queen Mary's dollhouse.

■ National Science Museums of Scotland
Chambers Street
Edinburgh
Scotland
United Kingdom
EH1 1JF

■ National Technical Museum
Kostelni 42
17078 Prague 7
Czech Republic
<http://www.radio.cz/ntm/ain terka.htm>

The photography and film section of this museum contains over 2,500 objects. The display also incorporates several hands-on demonstrations.

■ Naylor Museum
P.O. Box 23
Waltham Station
Boston, Massachusetts
02254

■ Royal Photographic Society
The Octagon
Milsom Street
Bath
United Kingdom
BA1 1DN
<http://www.rps.org>

The society operates a photographic gallery and a museum in the Octagon Galleries in the heart of historic Bath.

■ Science Museum
Exhibition Road
London
United Kingdom
SW7
<http://www.nmsi.ac.uk>

■ University of California at Riverside
California Museum of Photography
The Bingham Technology Collection
Riverside, California
U.S.A.
<http://www.cmp.ucr.edu/cam eras>

Dr. Robert Bingham donated the core of this collection to the museum in 1973. The collection of more than 10,000 items is reputed to be one of the three top collections of photo equipment in the world. It is ranked just behind the Eastman House and the Smithsonian Institution's collections. The museum also hosts the Kibbey Zeiss-Ikon Collection, the Curtis Polaroid Collection and the Wodinsky Ihagee-Exacta collection. These three collections contain examples of every camera produced by each company. The Bingham Technology Collection also hold Stereo Realist prototypes, two 1888 Kodak cameras and a Simon Wing multiple-lens wet plate camera.

APPENDIX II
RESOURCES

■ BOOKS

Bower, Brian. *Leica Lens Book.* D&C Publishing, 1998.
—— *Leica m Photography.* D&C Publishing, 1998.
—— *Leica Reflex Photography: New Edition Featuring the Leica R8.* D&C Publishing, 1997.
Comon, Paul. *Pentax Classic Cameras.* Silver Pixel Press, 1999.
Evans, Arthur. *Collector's Guide to Rollei Cameras.* Watson-Guptill, 1986.
Lind, Barbara (ed.), James M. McKeown and Joan C. McKeown. *Lind's List Camera Price Guide and Master Data Catalog 1996-97.* Amphoto, 1997.
McKeown, James M. and Joan C. McKeown. *Price Guide to Antique and Classic Cameras 1999-2000.* Centennial Photo Service, 2000.
Mantale, Ivor. *Collecting and Using Classic Cameras.* Thames & Hudson, 1992.
—— *Collecting and Using Classic SLRs.* Thames & Hudson, 1997.
McBroom, Michael. *McBroom's Camera Bluebook: A Complete Up-To-Date Price and Buyer's Guide for New & Used Cameras, Lenses, and Accessories.* Amherst Media, 1999.
Sartorius, Ghester. *Identifying Leica Cameras: The Complete Pocket Guide to Buying and Selling Leicas Like an Expert.* Amphoto, 1997.
—— *Identifying Leica Lenses: The Complete Pocket Guide to Buying and Selling Leicas Lenses Like an Expert.* Amphoto, 1999.
Tomosy, Thomas. *Camera Maintenance & Repair: Book 1.* Amherst Media, 1997.
—— *Camera Maintenance & Repair: Book II.* Amherst Media, 1998.
—— *Leica Camera Repair Handbook.* Amherst Media, 1999.
—— *Nikon Camera Repair Handbook.* Amherst Media, 2000.
—— *Restoring Classic and Collectible Cameras.* Amherst Media, 1998.
—— *Restoring the Great Collectible Cameras.* Amherst Media, 1999.

■ **PERIODICALS**

Camera Shopper (monthly periodical filled articles on classic cameras and classified ads for cameras and photographic equipment)

Shutterbug (monthly periodical featuring articles on photography and hundreds of advertisements from vendors selling used and new photographic equipment)

The Trader's Edge (tracks about 15,000 used camera and accessory prices by region)

■ **PARTS, TOOLS, REPAIR AND RESTORATION**

The information listed in this section is provided as a resource for the reader. No endorsement of these companies' or individuals' products or work is stated or implied.

Camera Bellows, Ltd. (stock and custom bellows)
Runcorn Works
2 Runcorn Rd.
Birmingham 12, England

Camline Industries (photographic test equipment)
PO Box 406
Running Springs, CA 92382 USA

Edmund Scientific (tools, optics)
101 E. Gloucester Pike
Barrington, NJ 08007 USA

The Focal Point (lens recoating)
1027 South Border Rd. #E-1
Louisville, CO 80027 USA

Golden Touch (screw-mount Leica parts, service)
118 Purgatory Rd.
Campbell Hall, NY 10916 USA

Photo Parts Source (parts, service manuals)
29659 US hwy 40W
Golden, CO 80401 USA

Western Bellows Co. (custom bellows)
9340 7th St., suite G
Rancho Cucamonga, CA 91730-5664 USA

■ **PHOTOGRAPHIC EQUIPMENT MANUFACTURERS**

All addresses listed below are for the US branch of the manufacturer. Many manufacturers have separate divisions in Canada and Europe.

Web and internet information was correct at the time of publication. If a dite has since moved, it can usually be tracked down using one of the many internet search engines.

Agfa
<http://www.agfanet.com>

Ansco Photo Optical Co.
1801 Touhy Ave.
Elk Grove Village, IL 60006

Beseler
<http://www.beseler-photo.com>

Bogen Photo Marketing (Metz, Gitzo, Gossen)
565 E. Crescent Ave.
P.O. Box 506
Ramsey, NJ 07446
<http://www.bogenphoto.com>

Bronica
<http://www.tamron.com>

Canon USA
One Canon Plaza,
Lake Success, NY 11042
<http://www.usa.canon.com>

Casio
<http://www.casio.com>

Contax
<http://www.contaxcameras.com>

Eastman Kodak Co. (Kodak, Wratten)
800 Lee Rd.
Rochester, NY 14650
<http://www.kodak.com>

Fuji Photo Film USA (Fuji, Fujica, Fujinon)
555 Taxter Rd.
Elmsford, NY 10523
<http://www.fujifilm.com>

Hasselblad, Inc. (Hasselblad, Softar)
10 Madison Rd.
Fairfield, NJ 07006
<http://www.hasselbladusa.com>

Ilford Photo Corp.
<http://www.ilford.com>

Kalimar, Inc.
622 Goddard Ave.
Spirit of St. Louis Airport
Chesterfield, MO 63005

Konica USA, Inc.
440 Sylvan Ave.
Englewood Cliffs, NJ 07632
<http://www.konica.com>

Kyocera International, Inc. (Kyocera, Contax, Zeiss, Yashica)
100 Randolph Rd.
Somerset, NJ 08875

Leica Camera, Inc.
156 Ludlow Ave.
North Vale, NJ 07647
<http://www.leica-camera.com>

Lindahl
<http://www.lslindahl.com>

Lowepro
<http://www.lowepro.com>

Lumedyne
<http://www.lumedyne.com>

Mamiya America Corp.
<http://www.mamiya.com>

Minolta Corp. (Minolta, Cokin)
101 Williams Dr.
Ramsey, NJ 07446
<http://www.minoltausa.com>

Minox
<http://www.minox.com>

Nikon, Inc.
1300 Walt Whitman Rd.
Melville, NY 11747-3064
<http://www.nikonusa.com>

Olympus Corp. (Olympus, Zuiko)
2 Corporate Center Dr.
Melville, NY 11747-3157
<http://www.olympus.com>

Panasonic Industrial Co.
Two Panasonic Way 7A-1
Secaucus, NJ 07094
<http://www.panasonic.com>

Pentax Corp.
35 Inverness Dr. E.
Englewood, CO 80112

<http://www.pentax.com>

Polaroid Co.
575 Technology Square
Cambridge, MA 02139
<http://www.polaroid.com>

Ricoh Corporation
475 Lilliard Dr. #101
Sparks, NV 89434
<http://www.ricohcpg.com>

Rollei Fototechnic
<http://www.rolleifoto.com>

Samsung Optical Co.
40 Seaview Dr.
Secaucus, NY 07094
<http://www.simplyamazing.com>

Schneider Optics
<http://www.schneideropticst.com>

Sekonic
<http://www.sekonic.com>

Sigma Co. of America
15 Fleetwood Court
Ronkonkoma, NY 11779
<http://www.sigmaphoto.com>

Sinar Bron, Inc.
17 Progress St.
Edison, NJ 08820

Sony
<http://www.sony.com>

Sunpak
<http://www.sunpak.com>

Tamron Industries, Inc.
99 Seaview Boulevard
Port Washington, NY 11050
<http://www.tamron.com>

Tiffen
<http://www.tiffen.com>

Toyo
<http://www.toyoview.com>

Vivitar Corporation
1280 Rancho Conejo Blvd.
Newbury Park, CA 91320
<http://www.vivitarcorp.com>

White Lightning
<http://www.white-lightning.com>

Yashica
<http://www.yashica.com>

INDEX

6th Edition

McBroom's Camera Bluebook

THE COMPLETE, UP-TO-DATE PRICE AND BUYER'S GUIDE FOR NEW & USED CAMERAS, LENSES, AND ACCESSORIES

Revised & Updated

McBroom's Camera Bluebook
6th Edition

IN STOCK! – All the camera price and buyer's information you need in one convenient, up-to-date volume. This edition is revised and expanded to include the latest models and prices, plus new sections on APS and digital cameras. The easy to use rating system has both new and used prices for more than 400 cameras, lenses, strobes, exposure meters and accessories. Also features detailed, fully-illustrated descriptions and comparisons of all major camera and lens lines – Canon, Nikon, Hasselblad, Leica, Minolta, Pentax, Rollei and more. $29.95 list, 8½x11, 336p, over 300 photos, McBroom, order no. 1553

"This book is about photo gear people buy to use." (p. 7)	"...optics by the better independents can represent a real value..." (p. 160)
"...before investing in digital imaging equipment, you really need to ask yourself a few questions..." (p. 278)	"...forty year-old Rolleis still see daily use world-wide..." (p. 225)

FEATURES:

• 35mm Cameras: Canon, Contax/Yashica, Leica, Minolta, Nikon, Olympus, Pentax,Nikonos and more

• APS Cameras: Canon, Minolta, Nikon and more

• Panoramic Cameras: Bogen Horizon, Noblex and Widelux

• Medium Format: Bronica, Fuji, Graflex, Hasselblad, Kiev, Mamiya, Pentax, Rollei, Yashica, Zeiss and more

• Large Format: Agfa/Ansco, Calumet, Deardorff, Gowland, Graflex, Kodak, Omega, Sinar, Toyo, Wisner and more

• Digital Cameras: Canon, Fuji, Kodak, Minolta, Nikon and more

• Aftermarket Lenses: Angenieux, Kiron, Sigma, Tamron, Tokina & more

Other Books from
Amherst Media™

Camera Maintenance & Repair Book 1

Thomas Tomosy

An illustrated guide by a master camera repair technician. Includes: testing camera functions, general maintenance, basic tools and where to get them, basic repairs for accessories, camera electronics, plus "quick tips" for maintenance and more! $29.95 list, 8½x11, 176p, 100+ photos, order no. 1158.

Camera Maintenance & Repair Book 2

Thomas Tomosy

Build on the basics covered Book 1, with advanced techniques. Includes: mechanical and electronic SLRs, zoom lenses, medium format cameras, and more. Features models not included in the Book 1. $29.95 list, 8½x11, 176p, 150+ photos, charts, tables, appendices, index, glossary, order no. 1558.

Restoring the Great Collectible Cameras (1945-70)

Thomas Tomosy

More step-by-step instruction on how to repair collectible cameras. Covers postwar models (1945-70). Hundreds of illustrations show disassembly and repair. $34.95 list, 8½x11, 128p, 200+ photos, index, order no. 1573.

Restoring Classic & Collectible Cameras (Pre-1945)

Thomas Tomosy

Step-by-step instructions show how to restore a classic or vintage camera. Repair mechanical and cosmetic elements to restore your valuable collectibles. $34.95 list, 8½x11, 128p, 175 photos and illus., glossary, index, order no. 1613.

Basic 35mm Photo Guide, *5th Edition*

Craig Alesse

Great for beginning photographers! Designed to teach 35mm basics step-by-step — completely illustrated. Features the latest cameras. Includes: 35mm automatic, semi-automatic cameras, camera handling, *f*-stops, shutter speeds, and more! $12.95 list, 9x8, 112p, 178 photos, order no. 1051.

Build Your Own Home Darkroom

Lista Duren & Will McDonald

This classic book teaches you how to build a high quality, inexpensive darkroom in your basement, spare room, or almost anywhere. Includes valuable information on: darkroom design, woodworking, tools, and more! $17.95 list, 8½x11, 160p, 50 photos, many illustrations, order no. 1092.

Into Your Darkroom Step-by-Step

Dennis P. Curtin

This is the ideal beginning darkroom guide. Easy to follow and fully illustrated each step of the way. Includes information on: the equipment you'll need, set-up, making proof sheets and much more! $17.95 list, 8½x11, 90p, hundreds of photos, order no. 1093.

Make Money with Your Camera

David Neil Arndt

Learn everything you need to know in order to make money in photography! David Arndt shows how to take highly marketable pictures, then promote, price and sell them. Includes all major fields of photography. $29.95 list, 8½x11, 120p, 100 b&w photos, index, order no. 1639.

Leica Camera Repair Handbook

Thomas Tomosy

A detailed technical manual for repairing Leica cameras. Each model is discussed individually with step-by-step instructions. Exhaustive photographic illustration ensures that every step of the process is easy to follow. $39.95 list, 8½x11, 128p, 130 b&w photos, appendix, order no. 1641.

Guide to International Photographic Competitions

Dr. Charles Benton

Remove the mystery from international competitions with all the information you need to select competitions, enter your work, and use your results for continued improvement and further success! $29.95 list, 8½x11, 120p, 60 b&w photos, index, appendices, order no. 1642.

Freelance Photographer's Handbook

Cliff & Nancy Hollenbeck

Whether you want to be a freelance photographer or are looking for tips to improve your current freelance business, this volume is packed with ideas for creating and maintaining a successful freelance business. $29.95 list, 8½x11, 107p, 100 b&w and color photos, index, glossary, order no. 1633.

How to Shoot and Sell Sports Photography

David Arndt

A step-by-step guide for amateur photographers, photojournalism students and journalists seeking to develop the skills and knowledge necessary for success in the demanding field of sports photography. $29.95 list, 8½x11, 120p, 111 photos, index, order no. 1631.

How to Operate a Successful Photo Portrait Studio

John Giolas

Combines photographic techniques with practical business information to create a complete guide book for anyone interested in developing a portrait photography business (or improving an existing business). $29.95 list, 8½x11, 120p, 120 photos, index, order no. 1579.

Computer Photography Handbook

Rob Sheppard

Learn to make the most of your photographs using computer technology! From creating images with digital cameras, to scanning prints and negatives, to manipulating images, you'll learn all the basics of digital imaging. $29.95 list, 8½x11, 128p, 150+ photos, index, order no. 1560.

Achieving the Ultimate Image

Ernst Wildi

Ernst Wildi teaches the techniques required to take world class, technically flawless photos. Features: exposure, metering, the Zone System, composition, evaluating an image, and more! $29.95 list, 8½x11, 128p, 120 b&w and color photos, index, order no. 1628.

Black & White Portrait Photography

Helen T. Boursier

Make money with b&w portrait photography. Learn from top b&w shooters! Studio and location techniques, with tips on preparing your subjects, selecting settings and wardrobe, lab techniques, and more! $29.95 list, 8½x11, 128p, 130+ photos, index, order no. 1626

Family Portrait Photography

Helen Boursier

Learn from professionals how to operate a successful portrait studio. Includes: marketing family portraits, advertising, working with clients, posing, lighting, and selection of equipment. Includes images from a variety of top portrait shooters. $29.95 list, 8½x11, 120p, 123 photos, index, order no. 1629.

The Art of Infrared Photography, *4th Edition*

Joe Paduano

A practical guide to the art of infrared photography. Tells what to expect and how to control results. Includes: anticipating effects, color infrared, digital infrared, using filters, focusing, developing, printing, handcoloring, toning, and more! $29.95 list, 8½x11, 112p, 70 photos, order no. 1052

Wedding Photojournalism

Andy Marcus

Learn the art of creating dramatic unposed wedding portraits. Working through the wedding from start to finish you'll learn where to be, what to look for and how to capture it on film. A hot technique for contemporary wedding albums! $29.95 list, 8½x11, 128p, b&w, over 50 photos, order no. 1656.

Studio Portrait Photography of Children and Babies

Marilyn Sholin

Learn to work with the youngest portrait clients to create images that will be treasured for years to come. Includes tips for working with kids at every developmental stage, from infant to pre-schooler. Features: lighting, posing and much more! $29.95 list, 8½x11, 128p, 60 photos, order no. 1657.

Professional Secrets of Wedding Photography

Douglas Allen Box

Over fifty top-quality portraits are analyzed to teach you the art of professional wedding portraiture. Lighting diagrams, posing information and technical specs are included for every image. $29.95 list, 8½x11, 128p, order no. 1658.

Photographer's Guide to Shooting Model & Actor Portfolios

CJ Elfont, Edna Elfont and Alan Lowy

Learn to create outstanding images for actors and models looking for work in fashion, theater, television, or the big screen. Includes the business, photographic and professional information you need to succeed! $29.95 list, 8½x11, 128p, 100 photos, order no. 1659.

Photo Retouching with Adobe® Photoshop®

Gwen Lute

Designed for photographers, this manual teaches every phase of the process, from scanning to final output. Learn to restore damaged photos, correct imperfections, create realistic composite images and correct for dazzling color. $29.95 list, 8½x11, 120p, 60+ photos, order no. 1660.

Creative Lighting Techniques for Studio Photographers

Dave Montizambert

Master studio lighting and gain complete creative control over your images. Whether you are shooting portraits, cars, table-top or any other subject, Dave Montizambert teaches you the skills you need to confidently create with light. $29.95 list, 8½x11, 120p, 80+ photos, order no. 1666.

Storytelling Wedding Photography

Barbara Box

Barbara and her husband shoot as a team at weddings. Here, she shows you how to create outstanding candids (which are her specialty), and combine them with formal portraits (her husband's specialty) to create a unique wedding album. $29.95 list, 8½x11, 128p, 60 b&w photos, order no. 1667.

Fine Art Children's Photography

Doris Carol Doyle and Ian Doyle

Learn to create fine art portraits of children in black & white. Included is information on: posing, lighting for studio portraits, shooting on location, clothing selection, working with kids and parents, and much more! $29.95 list, 8½x11, 128p, 60 photos, order no. 1668.

Basic Scanning Guide For Photographers and Creative Types

Rob Sheppard

This how-to manual is a hands-on workbook that offers practical knowledge of scanning. It also includes excellent sections on the mechanics of scanning and scanner selection. $17.95 list, 8½x11, 96p, 80 photos, order no. 1708.

Nikon Camera Repair Handbook

Thomas Tomosoy

Nikon cameras have come to epitomize the camera collector's dream. From body to lenses to internal mechanics and accessories, this book shows the reader how to repair, restore and maintain Nikon equipment. $39.95 list, 8½x11, 144p, 225 b&w photos, order no. 1710.

Medium Format Cameras: User's Guide to Buying and Shooting

Peter Williams

An in-depth introduction to medium format cameras and the photographic possiblities they offer. This book is geared toward intermediate to professional photographers who feel limited by the 35mm format. $19.95 list, 8½x11, 112p, 50 photos, order no. 1711.

Basic Digital Photography

Ron Eggers

Step-by-step text and clear explanations teach you how to select and use all types of digital cameras. Learn all the basics with no-nonsense, easy to follow text designed to bring even true novices up to speed quickly and easily. $17.95 list, 8½x11, 80p, 40 b&w photos, order no. 1706.

Make-Up Techniques for Photography

Cliff Hollenbeck

Step-by-step text paired with photographic illustrations teach you the art of photographic make-up. Learn to make every portrait subject look his or her best with great styling techniques for black & white or color photography. $29.95 list, 8½x11, 120p, 80 full color photos, order no. 1707.

AMHERST MEDIA'S CUSTOMER REGISTRATION FORM

Please fill out this sheet and send or fax to receive free information about future publications from Amherst Media.

CUSTOMER INFORMATION

DATE

NAME

STREET OR BOX #

CITY STATE

ZIP CODE

PHONE ()

OPTIONAL INFORMATION

I **BOUGHT** *How to Buy and Sell Used Cameras* **BECAUSE**

I FOUND THESE CHAPTERS TO BE MOST USEFUL

I PURCHASED THE BOOK FROM

City State

I WOULD LIKE TO SEE MORE BOOKS ABOUT

I PURCHASE BOOKS PER YEAR

ADDITIONAL COMMENTS

FAX to: 1-800-622-3298

CUT ALONG DOTTED LINE ✄

Name_____
Address_____
City_____State_____
Zip_____ — _____

Place
Postage
Here

Amherst Media, Inc.
PO Box 586
Amherst, NY 14226